FIFTY HOUSES

THE ROAD AND AMERICAN CULTURE

Drake Hokanson
SERIES EDITOR

Karl Raitz
CONSULTING EDITOR

George F. Thompson
SERIES FOUNDER
AND DIRECTOR

Published in cooperation
with the Center for American
Places, Santa Fe, New Mexico,
and Harrisonburg, Virginia

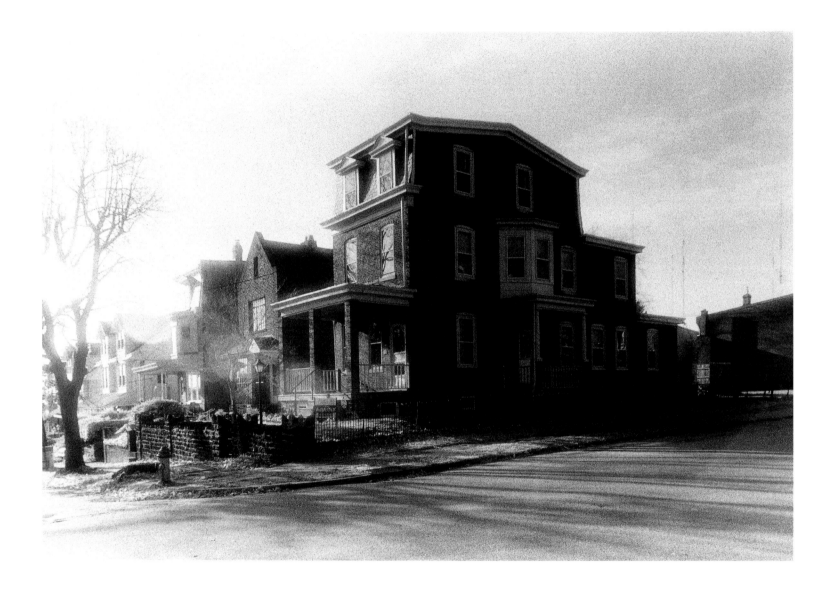

FIFTY HOUSES

IMAGES FROM THE AMERICAN ROAD

SANDY SORLIEN

WITH A FOREWORD BY
WILLIAM LEAST HEAT-MOON

THE JOHNS HOPKINS UNIVERSITY PRESS
BALTIMORE AND LONDON

Excerpt from "Edward Hopper and the House by the Railroad (1925)"
from *Wild Gratitude* by Edward Hirsch, Alfred A. Knopf, publisher.
Copyright ©1985 by Edward Hirsch. Used by permission of Alfred A.
Knopf, a division of Random House, Inc..

Excerpt from *A Field Guide to American Houses* by Virginia and Lee
McAlester, copyright © 1984 by Virginia Savage and Lee McAlester.
Used by permission of Alfred A. Knopf, a division of Random House,
Inc.

Quotation from "Mel Profitt," a character in the television series
Wiseguy, used by permission of Stephen J. Cannell.

The Johns Hopkins University Press
2715 North Charles Street
Baltimore, Maryland 21218-4363
www.press.jhu.edu

Library of Congress Cataloging-in-Publication Data

Sorlien, Sandy, 1954–

 Fifty houses : images from the American road / Sandy Sorlien ; with
a foreword by William Least Heat-Moon.

 p. cm. — (The road and American culture)

 Includes bibliographical references.

 ISBN 0-8018-7062-3 (hardcover : alk. paper)

 1. Dwellings—United States—States—Pictorial works.
2. Architectural photography—United States—States. 3. Travel photog-
raphy—United States—United States—States. 4. Architecture, Domes-
tic—United States—United States—States. I. Title. II. Series.

TR659.S667 2002

779'.473—dc21 2001008639

A catalog record for this book is available from
the British Library.

Frontispiece: My house, Philadelphia

For John

and the next generation of homeowners:
Kiri, Patri, and Mariel

In memory of my mother, Joanna;
Bill Hunt, my teacher; and
Stevie, my Cuz who loved houses too

Home is an addiction.

— MEL PROFITT

You rows of houses! you window-pierc'd façades! you roofs!
You porches and entrances! you copings and iron guards!
You windows whose transparent shells might expose so much!
You doors and ascending steps! you arches!
You gray stones of interminable pavements! you trodden crossings!
From all that has touch'd you I believe you have imparted to your-
 selves, and now would impart the same secretly to me,
From the living and the dead you have peopled your impassive
 surfaces, and the spirits thereof would be evident and amicable
 with me.

— WALT WHITMAN
Song of the Open Road

CONTENTS

PLATES

FOREWORD

WILLIAM LEAST HEAT-MOON

In spite of the ninety thousand miles over America that Sandy Sorlien traveled by auto, bicycle, and foot in her search for houses that evoke a nation we seem to be losing, she once wrote me, "Perhaps I could have meandered more and found better pictures." I like such an intense focus from a photographer, a dedication that borders on an artistic obsession with the external manifestation of the way we live when we are at home. Her devoted tenacity shows what we are too frequently blind or numb to. Such incognizance often results in our letting distinctive American domiciles slip away to be replaced by a blandness that further numbs us and removes deep connections with where we live out our lives, links with who we have been, are, will become.

In the early days of *Fifty Houses*, I left a selection of its photographs on my dining table for several days. Friends who happened by would pause over them, look through them, and, without exception, comment first not on Sorlien's evident artistry but on two or three of the homes that specially moved them. My friends would say something like, "Here's the one for me!" or

"This is a place I could wake up in each morning," or even "Do you think this one might be for sale?" *Fifty Houses* was a photographic Rorschach test wherein one could discover a concrete expression—in clapboard or stone, timber or stucco—of a dream theretofore only dimly perceived.

I realized that the collection is, indeed, a kind of dream book, not just in the otherworldly atmosphere that Sorlien summons up through her apparitional effects with infrared film or through the total exclusion of the humans who dwell within these houses, but also in the way certain of the pictures reach beyond to strike some chord of archetypal resonance. I catch myself thinking, "In a home like this, in some way, my days would proceed as never before." A moment later, I realize how nearly impossible these places seem today: the photographs expunge the ugly reality of powerlines, the sprawl of parking spaces, tawdry billboards, the clutter of automobiles, even hung-out laundry.

Sorlien's images—at least certain ones for each of us—can appeal to a viewer's notion of the ideal. We

may recognize, as children do when reading a fantasy, that these houses are not false so much as they appear, in our time at least, sadly improbable. In that way they are dreamlike. The cool and controlled art behind the photographs draws upon the deep and abiding power of dreams—not simply those of sleep but also those of our deepest longings. Of course, these homes do, happily, yet exist, as the photographs themselves attest. The structures truly and charmingly live in the realms of overhead lines, of sleeping dogs and parked station wagons, of snow and fog. The houses are certainly real, and so is our response to them, but it is only the latter reality that ultimately counts with those of us on the other side of these half-a-hundred front doors. That re-sponse, perhaps in itself, has a chance to help awaken us and cause us to resist, as Sorlien once wrote to me, "the dying of these old places." After all, her vision and art suggest—again in her words—that "it's the way we live now in America that is killing them."

You may see this collection as an elegy or a tribute. Those two words express the degree to which you believe that regional architecture and townscapes of America should be habitable not just for the body but also for the spirit. Those terms—*elegy* and *tribute*—perhaps indicate whether you see beauty and individual expression as enemies of economic profit and affluence or rather as integral parts of its fulfillment.

Columbia, Missouri

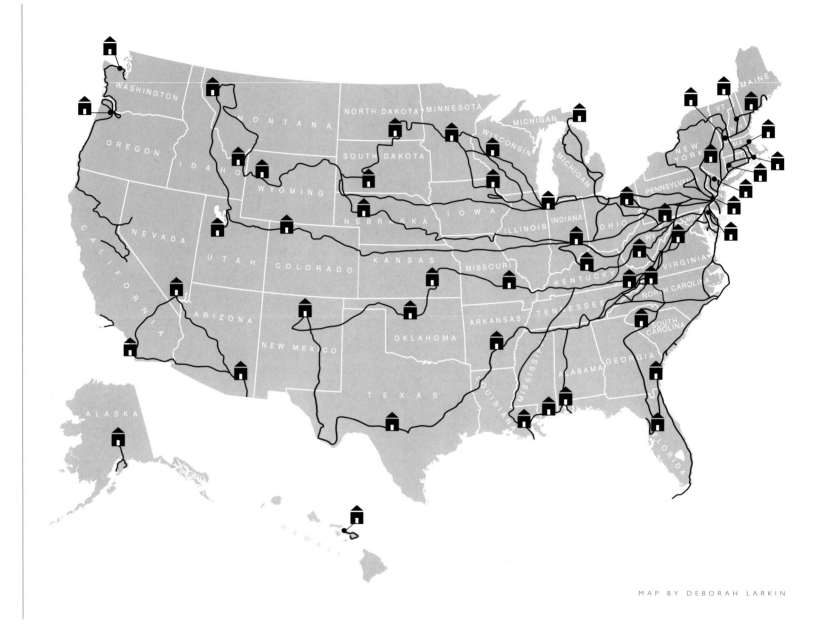

INTRODUCTION

Finding Fifty Houses

Americans move, on average, eleven times during their lives. Even those who stay put do a hell of a lot of driving. All things considered, we are the most mobile society in the world.

Among all the states, Pennsylvania, where I have always lived, boasts the highest percentage of natives who never move away. Arguably, then, Pennsylvanians may possess the strongest sense of place.

This contradiction is at the heart of my work. I leave home to find houses.

Over eight years, from 1988 to 1995 (and occasionally after that), I drove out of Philadelphia on some ninety thousand miles of American road, trips of two or three weeks' duration carrying me in increasingly far-flung trajectories westward. I'd take my bike, my hiking boots, my copy of Heat-Moon's *Blue Highways,* my cameras, and my darkroom chemicals. Forbidden by my own decree to drive on interstate highways, I'd cruise the secondary and back roads or park in the town centers and walk their streets. All the while I looked for houses, my head turning left, right, left, right, like a spectator at a tennis match.

The photographs chosen for this book represent one house from each of the fifty states. I decided to do this from the start because I wanted to travel through every state before America was completely defiled by subdivisions and parking lots. I was propelled in equal measure by this anxious wanderlust and by an inexpert but ardent fascination with houses.

Like many photographers, I'm a collector. We fix our sights on the things we admire and find a way to take them home with us. And like most photography, mine is also an act of preservation. Collecting these houses, the ones that reflect and define the place in which they stand, is my way of saving them. For they are going down . . . and soon they may be gone.

Anyone who travels in this country has seen it. Suburban tract homes and strip malls and big-box stores spread across America like melanoma. Downtowns are gutted for parking garages. The architecture is functional, cheap, and banal. The architectural landscape, especially in the sprawl zones, has become so homogenized that you can drive along an access road outside of Anchorage, Alaska, and it looks exactly like Oklahoma

City or Tucson or Jacksonville. I tell people that my next book will be *Fifty Pizza Huts*. I'll shoot the one down the street from me and print it fifty times.

By now, it is conventional wisdom that these appalling buildings are the legacy of America's dependence on the automobile and of the poor civic planning that has reinforced that dependence. Yet that doesn't entirely account for the mind-numbing blandness of the results. I would also implicate two of our favorite entitlements, television and air conditioning. Television has so homogenized our world that even the most backwater local news anchors have expunged their regional accents, and we all want the same things because we all see the same things, broadcast ad nauseam. Television has also replaced outdoor leisure to a frightening degree. When we don't go out in our neighborhoods, we stop caring what they look like.

Modern climate control also encourages our isolation from outdoor places. The use of air conditioning in the summer has even hastened the demise of that most wonderful of architectural appendages—the porch. Until the middle of the twentieth century, porches of all shapes and sizes were common, and nearly essential, in most regions of the United States. They were cool places to sit. Even homes without porches, like many southwestern and Hawaiian houses, tended to lie close to the landscape, tucked under the shade of the surrounding foliage. The new subdivisions, on the other hand, sport towering monstrosities you can see from miles away, exposed on their bulldozed, treeless plains.

Their front porches have been eliminated or replaced by graceless rear decks, which are hidden away so that no one on the street can see them or, God forbid, interact with the people sitting on them. Not that anyone actually walks the streets of suburbia.

Looking at my pictures, you may imagine a time when people used their front porches or stoops and strolled their pedestrian-friendly neighborhoods. The people may no longer do these things, but some of the houses are still here, on the rural back roads and in the small town centers and in the city neighborhoods of America. But we're losing the will to keep them, and for those of us who believe that physical place can shape the character of a life, that's a tragedy.

So, with a nearly desperate sense of loss, I set out in my Honda for points north, south, west, and farther west, looking for porches. And cupolas and dormers and cedar shakes and eyebrow windows and widow's walks. I found them on modest homes of no great importance as well as on some Nationally Registered Historic Places. Except for Hawaii (always exceptional), each state is represented in this book by a house that is now, or recently was, lived in. They're houses, not museums. And they're individuals, each with its own set of stories to tell. Sometimes I heard the stories; other times I had to move on. But there always seemed to be a good reason for that house being where it was.

Like many travelers, I'm fraught with the conflict between fidelity to my home and the allure of the distant. Traveling mostly by car to make my photographs,

I promote and ratify the same culture that neglects houses like these. I can't defend my methods completely, but I temper them by driving a small vehicle that averages thirty-five miles to the gallon and, whenever possible, by dining and sleeping in locally owned businesses, downtown.

But let's face it, these were road trips, and like any good roadster I reveled in the motion, in my blaring stereo (Steve Forbert across the South, Robert Earl Keen across the West, the Band in New England, James Brown everywhere), and in appreciation of goofy roadside attractions (the Mystery Hole in Ansted, W.V., and the World's Largest Buffalo in Jamestown, N.D.), bizarre signs ("Bassett, Nebraska: Number One in the Arts" and "Welcome to Historic Port Deposit [Md.]—Enjoy Our Terraces and Granite"), and one-of-a-kind town names (Thicketty, S.C.; Bat Cave, N.C.; Gnaw Bone, Ind.). As Forbert sings with an audible shrug, "I guess it's just / the American in me."

Yet my ultimate quarry was that symbol of stability, the house. I would spot one I wanted and slow down, pulling into the driveway and turning off the music before knocking on the door.

Hundreds of homeowners welcomed me onto their properties. "Have at it!" cried one man. In Stonington, Maine, Pam and Stephen Pace invited me in for tea and toured me around their farmhouse and barn studio; a year later I traded my photographs of their house for one of Stephen's woodcuts. Many of the people I met were retired and, often, alone. I did all my shooting in the daytime, and they were the ones who were home. I was bolstered by people like Ann Smith in Kenton, Ohio, who gave me Oreos and coffee and talked politics and encouraged me to get home where it was "safe," and Howard Crawford of Severy, Kansas, who showed me the snapshots he had taken of his new truck, then showed me the truck itself, then later mailed me some more photographs—again of his new truck and one of himself posing with a large pumpkin from his garden.

Fortunately, I never knocked on the door of the Manson house, and in all those years only one person refused me permission to photograph. As a woman, I was a relatively acceptable interloper, though I still encountered some suspicion ("I don't know why you'd want to photograph this old dump"), but most of the people seemed secretly pleased.

This kind of road trip is imbued with randomness and serendipity, yet routine was a necessary part of it. As each day wound down, I'd consult my map and pick a motel from the *AAA TourBook* or by sight, often asking to inspect the room first. I wasn't checking just for cleanliness but also to see whether the bathroom would be easy to darken. Virtually all of my film for *Fifty Houses* was processed in bathrooms on the road.

Immediately upon taking possession, I made the motel room my home, strewing my clothes and maps around and setting my clock and books on the nightstand. Some of these places were memorable in themselves, like a West Virginia motel called the Koolwink, which was deeply bedecked in olive green shag (includ-

ing the toilet seat cover), and the venerated, rustic Pine Tavern Lodge in the Blue Ridge Mountains. But I also stayed in my share of Motel Sixes on the strips, able to tell where I was only by the town name on the telephone book. Often there was no choice.

A typical evening (after a dinner out at a local café) was occupied by film development. I covered the bathroom windows, if there were any, with black plastic to keep out stray light. I mixed my chemicals to the proper temperature, if necessary immersing an electric coil in the developer. With the lights out and towels stuffed along the door jamb, I loaded the day's rolls of film onto reels and sealed them in a steel tank. The rest of the processing was done with the lights on, with the water running in the sink for the better part of an hour. It was important to see the day's work (if only in negative form) before I left the area, in case any reshooting was warranted.

Early the next morning I would cut up and file the dry negatives, ready for me to print upon my return to Philadelphia. Next I'd load my 35mm camera with Kodak high-speed infrared film, pack it in my bike trunk, and ride around town. I used either a 28mm or 35mm Nikkor perspective-control lens, depending on how far back I could get from my target house. (This project required a lot of standing in the middle of the street, with frequent lifesaving bailouts.) The PC lenses have rise, fall, and shift capability, like that of view cameras, most useful for correcting the convergence (or "keystoning") of parallel sides of a building that occurs when a wide-angle lens is tilted upward.

The infrared film, used for every image in this book, is sensitive to visible light and also to infrared light waves, which we can't normally see. I control the mix of the two kinds of light with a yellow or orange filter on the lens. The filter blocks some of the visible light while letting all the infrared pass through. Infrared accounts for the softened edges, whitened grass and foliage, and pronounced grain in the photographs. I've chosen this film because, when it works for me, I get a house portrait that evokes, paradoxically, both timelessness and evanescence.

I increased my chances of finding older homes with regional character by heading for towns with historic districts. Sometimes I'd simply use guidebooks to identify those places. Or people I met along the way would point me, or lead me, to the houses they thought were exceptional. Invariably these buildings were interesting, but it was a little like being fixed up on a blind date—if the light wasn't right at the moment I saw them, there was no spark. As it turned out, not one of the pictures in this book was the result of a recommendation. Most of them were simply spotted on the fly.

What was it really, that caused me to stop, cruising along a two-lane road somewhere? Light on geometry; dignity in the midst of indifference, defiance of impending death—or, perhaps more poignantly, acceptance of it. Somehow I could read these attitudes in the stance of an ordinary house. It acquired its character, like the humans who made it, over time. Nearly all of the houses I photographed were past middle age.

If I had to pick the towns in the United States with

the best houses, I could name quite a few. Like New Orleans, where I was virtually paralyzed by the daunting challenge of choosing among the hundreds of gems there. Or sublime Savannah, Georgia, which I visited too late for this book. Or Beaufort, North Carolina (*Bo*-fert), and Beaufort, South Carolina (*Bew*-fert); Mackinac Island, Michigan; Oak Park, Illinois; Santa Fe, New Mexico; Fredericksburg, Texas; Worcester, Massachusetts; Newport, Rhode Island; Richmond, Indiana; Mobile, Alabama; San Francisco, California; Guthrie, Oklahoma; Milledgeville, Georgia; and, of course, my hometown, Philadelphia. Every big city has hundreds of amazing houses, and I'm also leaving out lots of cities and towns I've never visited but that are known for their architecture, such as Richmond, Virginia; San Antonio, Texas; and Sainte Genevieve, Missouri.

I have been searching for authenticity. Yet my pictures, like all photographs, are misleading. They present a partial truth that fulfills a personal wish. The camera crops out all that I find to be crude, banal, and enervating about much of late-twentieth-century America's built environment. Sometimes a short swivel of the camera from where I am standing will show a tangle of utility wires, a garish forest of signs, the cartoon façades of fast-food huts, or an asphalt acre covered with cars. This rubbish is always lurking close by or in the near distance, threatening to engulf us like a relentless artificial kudzu.

If I can just keep it at bay in my photographs, then I have done something I feel powerless to do in any other way.

Philadelphia, Pennsylvania

FIFTY HOUSES

Sometimes it seems that a journey has barely begun when you hit a roadblock.

I was only thirty miles from home, but I'd never seen this place before. A detour brought me here; a stone bridge had been damaged during that wild winter, when huge blocks of ice had crashed along the Perkiomen Creek and piled up on land. I drove around on White's Mill Road.

I was on my way to visit a friend who was dying, far too young.

Later I took his dog to live with me in the city, and after that, whenever we drove near a stream in a wooded area, Chisel whined and whined. Even with the car windows closed, he must have been smelling those wet leaves. Chisel was named for the quarrying done in that part of Pennsylvania, and he knew where he was from.

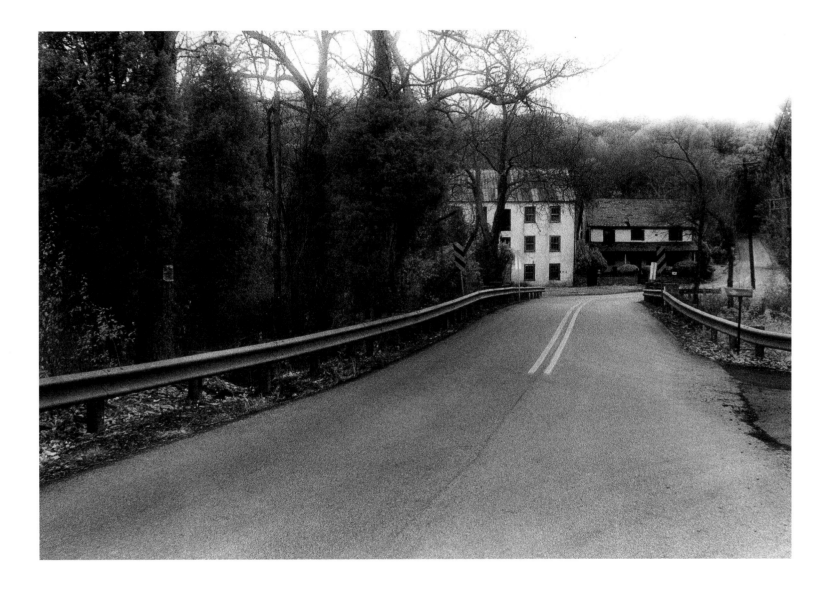

Like human relationships, some of my encounters with houses are fleeting and careless; some are the result of an immediate, intense attraction; and still others insinuate themselves gradually over many years. Good photographs arise from all kinds. This classic saltbox interested me when I first saw it, but not enough to photograph it until I'd seen it at least a dozen times over the course of a decade. It's across the road from a friend's house, a place I go when I most emphatically am not working. Often I don't even have my cameras with me.

Finally I went up and knocked, and the new owner told me of her relationship with her house. She said it was built in 1738 at another location, eventually disassembled, and reconstructed here in the early 1990s.

"You should shoot it through the trees," she suggested. "That's how I first saw it, from the road, driving by, and I decided right then that I wanted to live there."

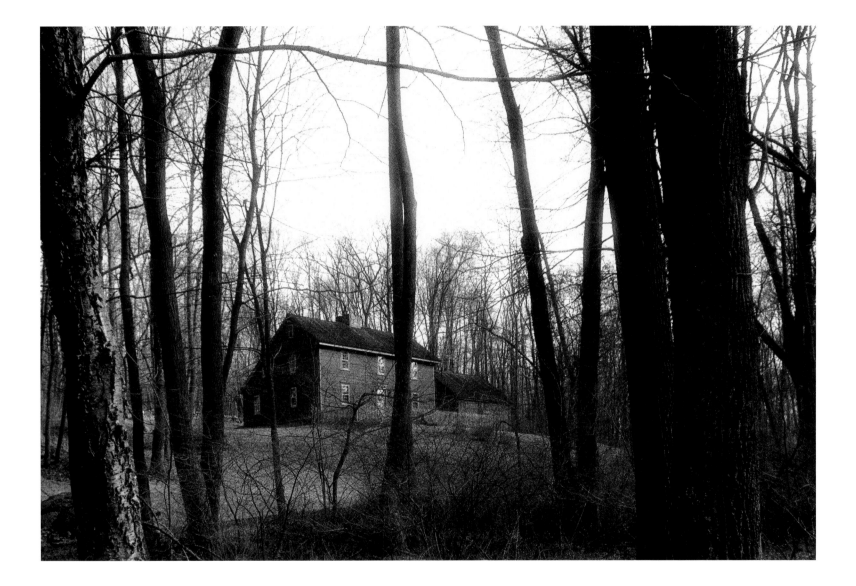

I made this photograph in 1990 and found myself in the area again ten years later. Curious, I drove through the Catskills to Middleburgh, sure I would find the rural fields around town infested with subdivisions. I figured that any place within commuting distance of Albany, the state capital, would have succumbed by then.

Amazingly, it hadn't happened. The only changes I saw to this view were shutters on all the windows (and one window walled over); also a nice paint job. And planted just to the left of the path was a young oak tree, blocking the house from my original camera position.

Well, there was a small indication that, at the millennial rollover, automobiles drive us, not the other way around. Just out of the frame to the right, where there had been meadow, was a paved parking area and a spanking new three-car garage.

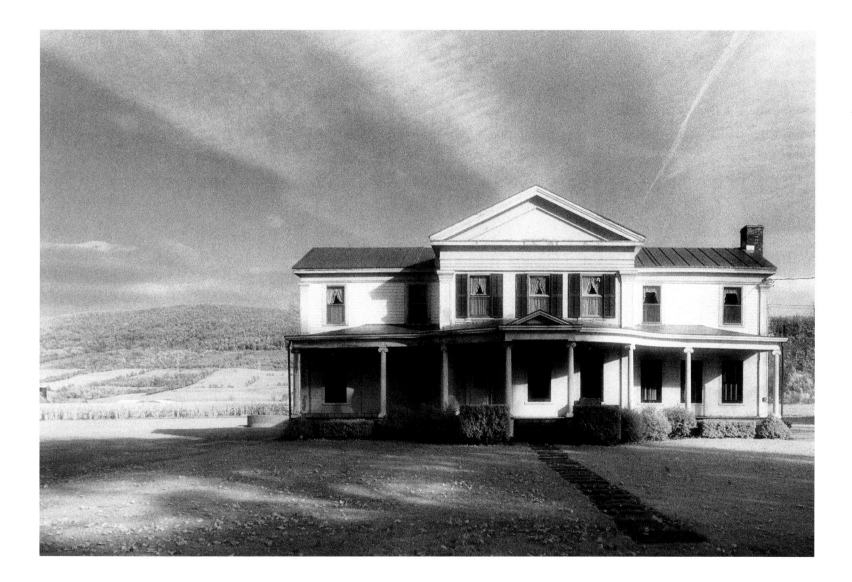

Clingstone, also known by the locals as "House on the Rocks," perches on a rocky islet in Narragansett Bay between Jamestown and Newport, accessible only by boat. Usually this view of the house would include the waterfront of Newport a mile off in the background, but a soupy New England fog has descended.

Clingstone is aptly named, for it has clung like a barnacle through numerous severe hurricanes. (The name "Barnacle," if it was ever considered, was already taken by a house nearby on the shore of Conanicut Island.) Clingstone was built in 1902–5 by Joseph Lovering Wharton, and plans for the twenty-three-room house were drawn by J. D. Johnston to provide extra hurricane protection. Interior features included shingled walls, massive beachstone fireplaces, and exposed white oak ship timbers from Tennessee, secured with wooden pins.

In September 1938, New England was surprised by the worst hurricane of the century. As the *Providence Journal* reported:

"Before night fell, 312 men, women and children were dead and missing in this State and on the immediately adjacent shores of Massachusetts summer resorts; $100,000,000 worth of damage had been wrought from Westerly to Sakonnet Point and inland; entire beach communities had been wiped from the map, the State's contour was changed, beaches had been obliterated, thousands of trees and utility poles felled, yacht fleets smashed, sunk and flung up hundreds of feet beyond high water, and the streets of downtown Providence buried to a depth of 10 feet and more beneath the waters of the Bay.

"Never in history had such a disaster visited these shores. No mere recital of statistics on damage and death could tell the story of that cyclonic madness . . ."

Clingstone was heavily damaged but still sound. Since then, the house has rebuffed the efforts of Hazel, Carol, Gloria, Bob, Floyd, and countless lesser storms.

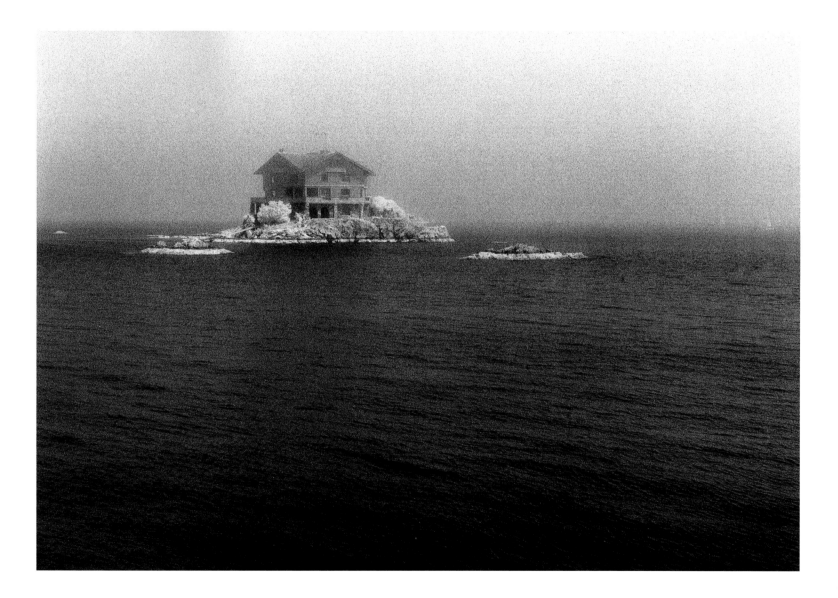

In Northampton, I heard an artist say, "That's the best gallery west of Worcester." As if it were a district, like TriBeCa or SoHo. WeWo. This also implied that there are, in fact, galleries in Worcester. I imagine this is the case, but the Worcester I explored seemed so thoroughly utilitarian that I would have been shocked to see one. It is Not Northampton (NoNo), not a place so gentrified and clogged with collegians and tourists that the primary business of its Main Street is browsing and sitting in sidewalk cafés watching others browse. In towns like that, the business of selling hardware and housewares and groceries takes place out in the sprawl zone, in WalMart, or in countless little strip malls, driving distances apart.

In truth, few American towns are exempt from that trend, and neither is Worcester. Even in an intact downtown neighborhood like this one, utilitarianism and short-sightedness allow the covering of Worcester's handsome three-story houses with vinyl or aluminum siding. The educated eye can distinguish siding from clapboard—a builder noticed it in this picture. In ten or fifteen years, when it starts to bleach and warp, everyone will notice it.

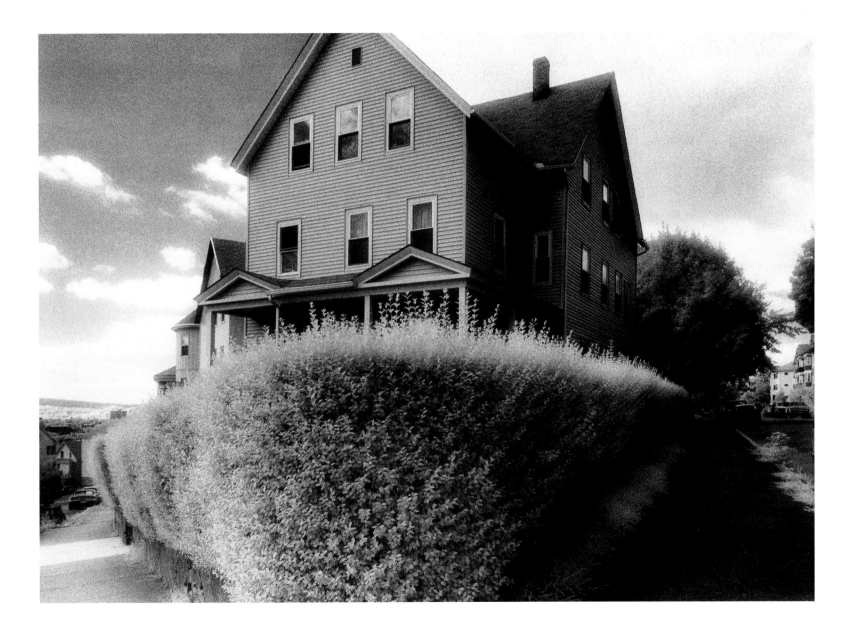

When I photographed the back of this former square-dance hall in 1994, it was owned by the Darrow family's Green Mountain Orchards. As it happened, I returned six years later just as new owners were moving in. They'd done extensive renovations, installing a lot more glass on this east side. The view from inside is heavenly. They were ecstatic about their house and surprised to be handed this "before" picture on their first weekend there.

Next door, Green Mountain Vice President Matt Darrow now rents his barn apartment from the newcomers. The sale of these buildings was part of an ongoing divestment of acreage from the orchard throughout the 1990s. Before that, Green Mountain was one of the five biggest apple orchards in Vermont. When I asked Matt why the family had to sell off land, statistics rolled off his tongue as he recounted the reasons:

"Cheap shipping—it makes more sense to grow apples in Chile, where they can use DDT and cheap labor, and ship them here. . . . Farmers are getting screwed in Washington, they don't have cartels, nobody's fighting for them. . . . The corporate takeover of food sales, so five or six companies control 90 percent of the food sales, and the five or six produce buyers for the whole East Coast can insist on lower prices from us. . . . Apples cost the same as they did thirty years ago, when my father ran the business, but the cost of doing business is $250,000 a year compared to $5,000 back then. . . . The liability insurance, land taxes, SSI, workman's comp, unemployment insurance are all mandatory. . . . When my grandfather first planted the upper orchard in 1914, trees were two cents apiece; now they're eight bucks. . . . All that, and we've been particularly hard hit by this ongoing strange weather thing; all farms are affected, but it's especially bad for apples."

He looked out his side window toward the renovated house. "But they're really nice people. Really nice."

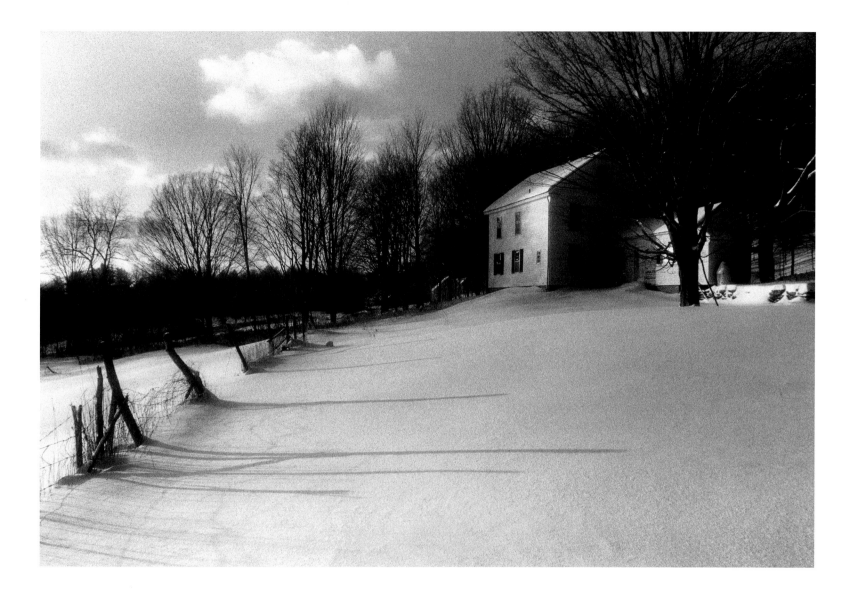

New England is famous for its add-on houses, prevalent in a region of three-hundred-year-old buildings and long, harsh winters. As a homeowner's prosperity grew, he would seek to increase his interior space, most desirable in a cold climate. The end (or evolving) result: a bigger place where you don't have to go outside to visit the barn, the shed, the studio, or the bathroom.

This one is typical of the style, although this view doesn't show all its ramifications. My cousin Roger Sorlien, who lives nearby, writes:

"The house is in the section of Sandwich which was formerly known as Lower Corner. Every part of the town had its own name in the 1800s when travel was slow and the town had a bunch of schoolhouses scattered about. The original house was built by Isaac Adams who made his money off the invention of a cylinder printing press. There was a beautiful stand of chestnuts on the property and at some point the place was called Chestnut Farm and [that] soon changed to Chestnut Manor, . . . which it is still [called] today. At least four other local houses were added on to make the main house. The attached barns go on forever. There is a great windmill to the left of the front of the house and one of the barns has a bowling alley in it.

"It would be safe to say the house was built over the course of 40 years from the 1830s to the 1870s, discounting the fact that some parts of it are even older because of the house-moving practices of Yankees."

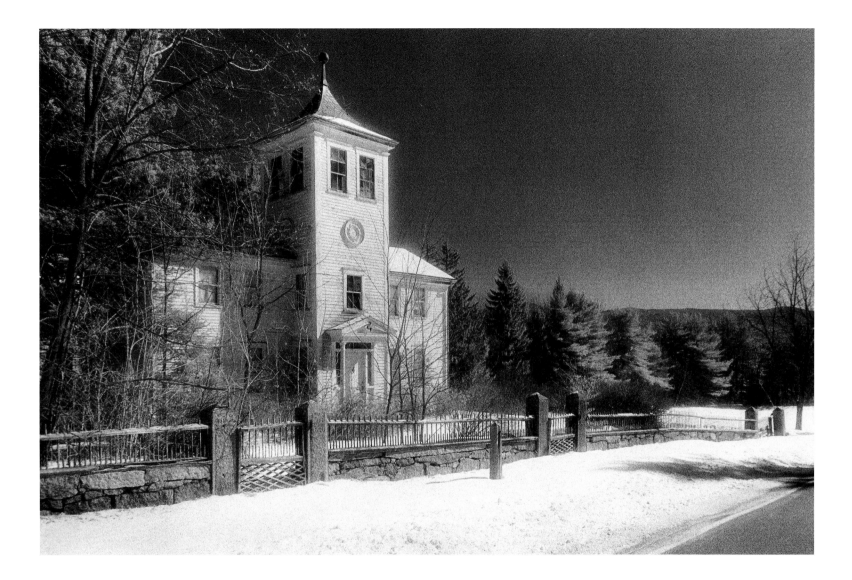

I drove to New England in 1988 on a short, prototype trip to see how my shooting and developing methods would work on the road. Using motel bathrooms as my darkrooms, I managed to fog several rolls of infrared film because light was getting in through the windows, even at night. After that, I always took along a roll of black plastic.

I stopped at a 150-year-old house in South Thomaston; the owner ambled out to smoke a cigarette and chat while I worked. He said lots of people stopped to photograph the house, that it was even in a book once, as an example of an add-on house.

I stopped at another old farmhouse in South Thomaston. The owner said, "Sure, you can take a photo, everybody does. Lots of people stop but hardly anyone asks permission. You know, [Andrew] Wyeth painted this house, and his students used to sit over on that hill and paint it."

I was getting the feeling that the area's houses were overappreciated. I returned to Portland several years later to make this urban house portrait.

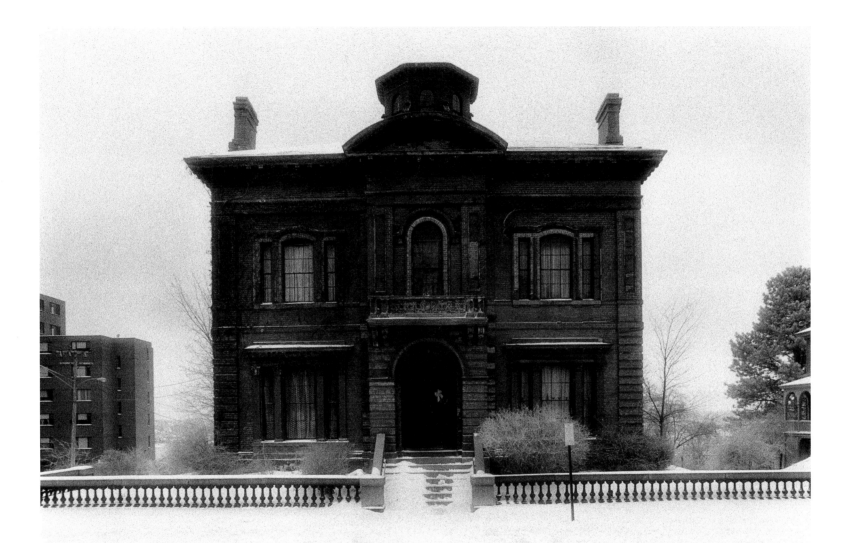

This northwestern corner of New Jersey is lushly beautiful and remarkably free of development. It should stay that way within the Delaware Water Gap National Recreation Area, where Peters Valley is nestled. But the fate of the original buildings there is another story.

Now a dormitory for the Peters Valley Craft Center, Lower Treible was built around 1900. In 1969, the U.S. government acquired the home from the Treible family in a massive takeover of property on both sides of the Delaware River for the proposed Tocks Island Dam. (I think if you look up the word *debacle* in the dictionary, there's a diagram of the Tocks Island project.) Peters Valley was one of the villages whose residents were completely cleared out. Local historian Kevin Perry writes that

"the project called for the displacement of hundreds of area residents and businesses, altering 37 miles of river, and destroying 10,000 acres of farmland, forests and wildlife habitat. All based on the theory that the hurricane-caused floods of 1955 could recur, though they were the first such floods since European settlement some 300 years earlier. The Tocks Island Lake Project was vehemently opposed by residents, historians and environmentalists. The rationale for TILP was arguable, the impacts were egregious, and the heavy-handed Army Corps of Engineers tactics were deplorable. While some residents were actively or passively encouraged/coerced to sell their properties, others had their homes condemned and taken with compensation. Some homes and other structures were bulldozed, including several historically or architecturally significant buildings."

After the Tocks Island plan was finally blocked in 1975, Lower Treible was made available to Peters Valley Craft Education Center (which was starting up in the newly vacant village) on a Special Use Permit from the National Park Service.

"Over time, the Permit gave [the Craft Center] increasing responsibility for its own maintenance and other needs. [But] it has a standard provision allowing termination on a 120-day notice. It is difficult to attract grants or donations for property restoration when you could theoretically be evicted in four months. . . . So we now have 35 buildings, some up to 200 years old, which must be maintained by two people. Despite their skills and devotion to doing good work, the task is simply overwhelming."

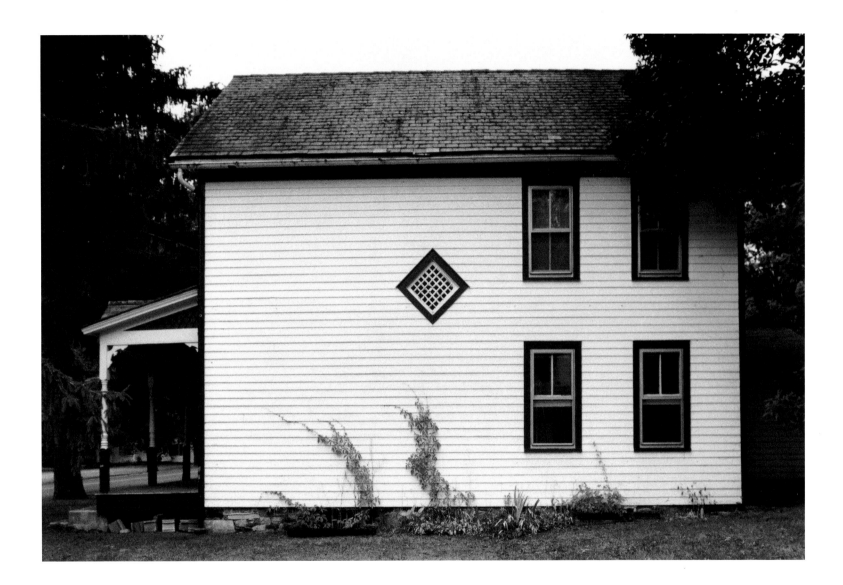

Hedgelawn was built in 1856 by John P. Cochran, later governor of Delaware from 1875 to 1879. It sits near two other Cochran houses in an area west of Middletown known as "The Levels." This is an almost perfectly flat expanse of land in a state whose highest elevation is only 448 feet. (Among all the states, only Florida's highest point is lower, but Louisiana gets an honorable mention for hyperbole: Its highest elevation, 535 feet, is the summit of "Driskill Mountain.") The Levels are a watershed of sorts; from here the creeks run east to the Delaware Bay and west to the Chesapeake.

Hedgelawn and its sister houses are called *peach mansions* to acknowledge that they were financed by profits from the peach crop. The year Hedgelawn was built was the year the Delaware Railroad began operating, connecting Middletown and western Delaware with the port on the Delaware Bay and adjoining canal. By 1875, Middletown was the state's peach-growing center, shipping thirty to fifty rail cars full of peaches every day of the harvest season.

Hedgelawn, an architectural mix of Greek Revival, Italianate Revival, and Georgian styles, remains essentially the same house it was in 1856.

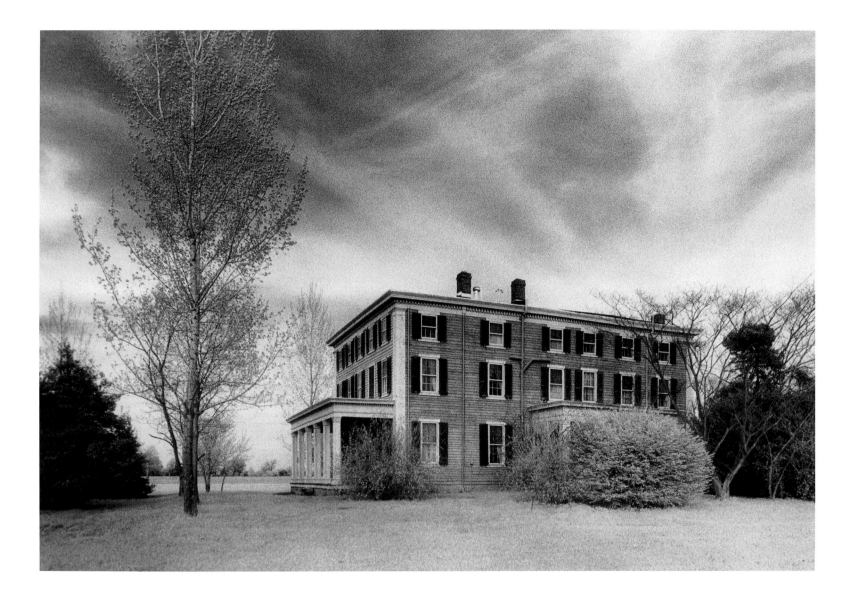

Maryland may be the smallest state to show marked extremes of landscape and architecture from one end to the other. Some might even say Maryland's Eastern Shore is another place altogether, separated from America by the Chesapeake Bay. It shares with Delaware (and a bit of Virginia) a peninsula of flat farmland, salt marshes, and ocean beaches, inclusive of islands where Elizabethan English is still spoken. Western Maryland, on the other hand, shares West Virginia's mountains and rivers and the Midwest's architecture. If you look at a map of the state, there are two places in the western section where it narrows so drastically that it almost cuts itself off. Cumberland is at one of these bottlenecks.

I photographed this house in November 1992, too early in the morning to rouse the inhabitants. Seven years later I was passing through Cumberland en route to Ohio and met the new owner. He was young and had recently returned home to Cumberland to buy this house, which he'd always liked. His graphic design firm takes up the second floor. When I came inside, he showed me an astonishing picture.

Now, the house is flanked and surrounded by a dense neighborhood of houses. But in the 1897 photograph, it stands startlingly alone in a cleared landscape. The only other building nearby is the Zihlman Glass Works. Anthony Zihlman had built the house a year before the picture had been taken.

I am entranced by the widow's walk on a landlocked house. Maybe they wanted to keep an eye on the Glass Works, or maybe they longed for the sea, standing up there on windy days trying to gaze two hundred miles to the Eastern Shore.

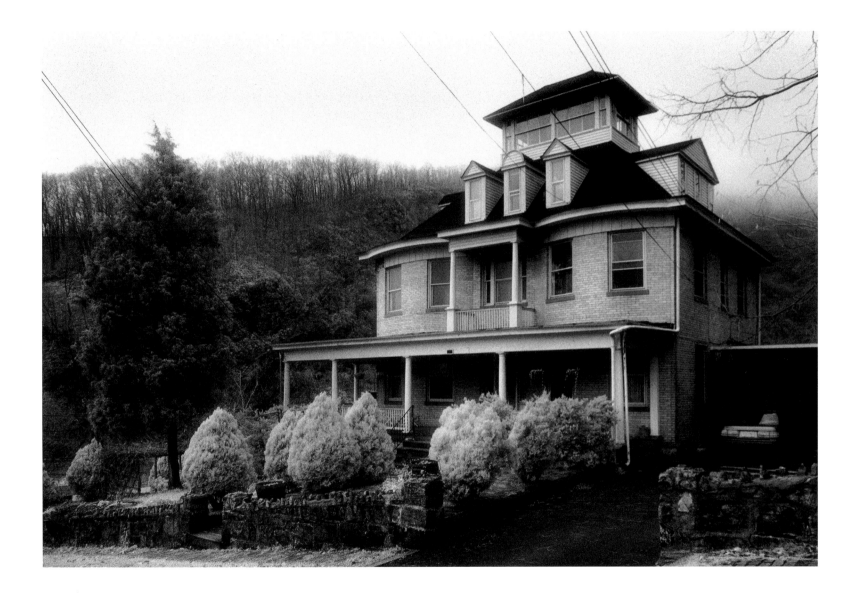

This is a famous house. People see this photograph and tell me confidently, "Oh, I know that place." Sometimes they do. It's called Montpelier (not James Madison's Montpelier), and it is pictured in a book called *Virginia Plantation Homes* by David King Gleason. But I didn't know that when I drove by it one winter morning and came to a screeching halt on a two-lane country road, instantly smitten. There it stood on a hill—pale gold, immense, and grand.

Somehow it remained unpretentious. The grounds were barren of landscaping, the farm buildings modest. But the house is huge. I returned here four times over three years trying to capture that sense of scale and grandeur and repeatedly failed. I would include the whole building in the frame, but it seemed so diminished on paper. During this period I went to an exhibit of photographs of industrial buildings by Albert Renger-Patzsch and learned that, to convey vast architectural scale, it is better to show only a part of the structure. The rest will be implied. Critic Donald Kuspit wrote of Renger-Patzsch that his work suggests "what Kant called the mathematical sublime: if the part is overwhelmingly gigantic, the whole must be all the more so."

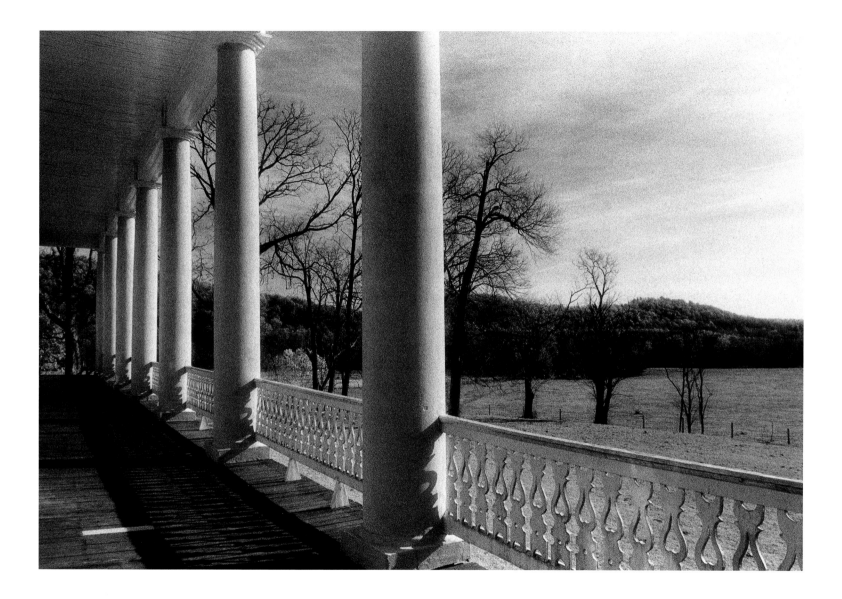

This house was one hundred years old when I took the picture in 1989. According to its owner, a retired schoolteacher, it's one of the two oldest houses in Alleghany County. She wasn't home when I first saw the house and photographed it, but I returned three years later to give her a print. As I introduced myself, my rapid Northern speech was too much for her. "I cain't understand a word you're sayin'," she cried. "You must be from overseas!" She offered me a Yoo-Hoo and we talked. Slower.

As I was leaving, she pointed down the road and insisted that I take a look at another place nearby. "You cain't miss it," she said, "it's got three little doghouses."

Being from overseas, I naturally thought she meant houses for dogs, but when I spotted a white farmhouse with three identical dormer windows across the top, I knew that was the place she meant.

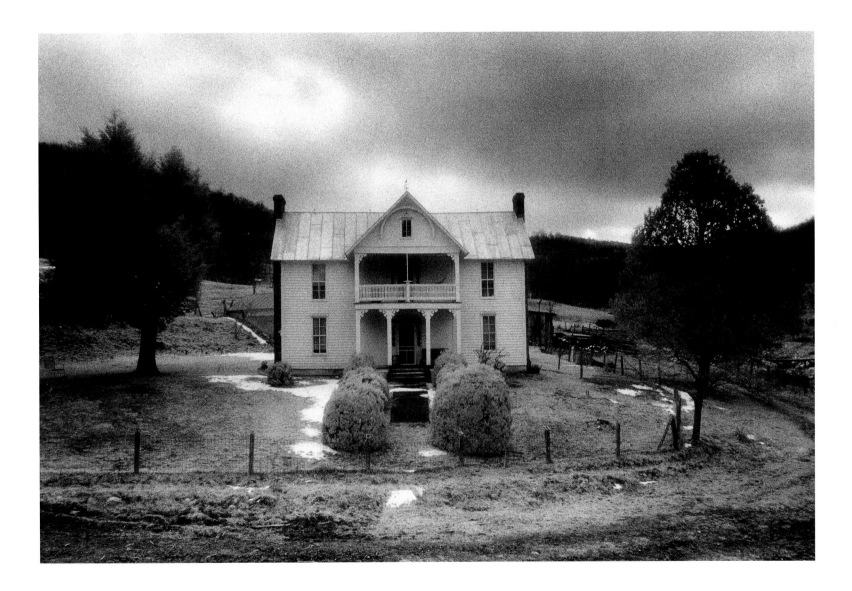

I spoke with the woman who lived here but neglected to get her name and address. Later, I wanted to send her a print and ask about the trees in the yard. Back home in Philadelphia, the only thing I could think of was to call the Mountville post office, which I remembered as being just down the street from the house.

I got the postal clerk on the phone and said, "If I send you a photograph of a house in Mountville, will you recognize it and put it in the right mailbox?"

"No problem," she said, and it was done.

Answers came back shortly. *Left:* cedar of Lebanon. *Right:* magnolia. *House:* built in 1895 by the great-uncle of the present owners.

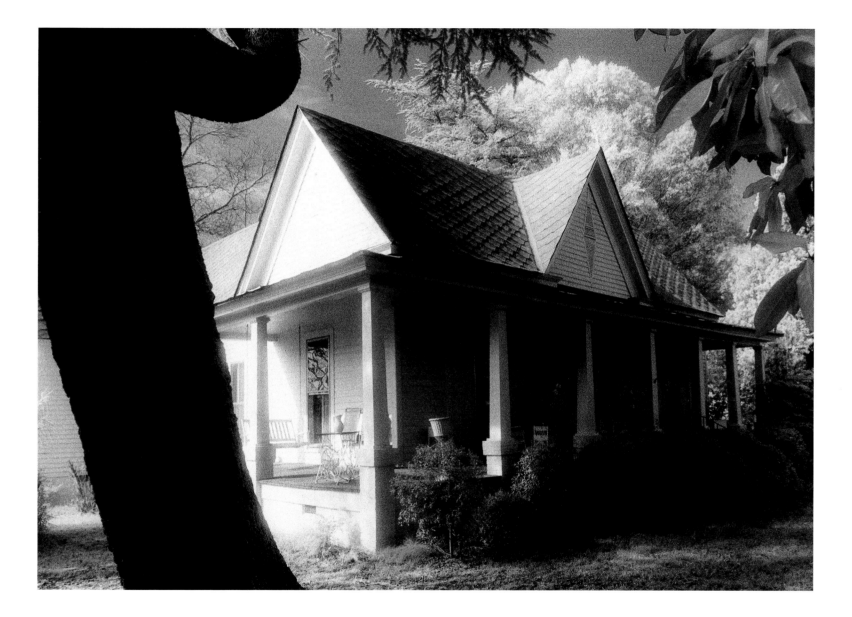

I pulled into Athens, a town wholly occupied (and pre-occupied) by the University of Georgia. It was a Saturday around 2:00 P.M. The streets were strangely deserted, with few cars and no pedestrians at all. The woman at the Welcome Center explained it: "The Bulldogs are home playing Auburn. You'll be fine until four o'clock; after that, lay low." I drove around town, admiring the antebellum mansions taken over by fraternities. Then, as I cruised through campus, I happened to glance over at the open stadium and saw . . . a virtual wall of red: DAWG FANS. It was a stunning and frightening sight. Even several blocks away, I kept hearing a sound like jets taking off. DAWG FANS, cheering. I hightailed it out of town, for it would clearly be a traffic nightmare to end them all, once the game ended (Auburn 20, Georgia 3).

A day later I came to Darien, where this place is visible from U.S. 17. The site and home have separate histories; this is not the original plantation house of the Butler Island Rice Plantation. Visitors today can still see evidence of the system of dikes and canals designed by engineers from Holland and the seventy-five-foot red brick rice mill chimney, built by slaves in the 1850s.

This house was built in 1926 in the popular Colonial Revival style by Colonel Tillinghast L'Hommedieu Huston, owner of the New York Yankees during the Babe Ruth–Lou Gehrig years. Legend has it that he brought players here during the off-season for hunting and fishing vacations.

Coastal McIntosh County, of which Darien is the county seat, boasts more than two hundred descendants of the original Scots settlers from 1736. Only one antebellum house remains in Darien; the rest were burned by Union soldiers (in the Civil War battle recounted in the motion picture *Glory*). Still, in 1989 the town retained a sleepy Southern flavor—many of its streets unpaved, sandy lanes.

That was no longer the case when I returned to Darien in 2002, but this house looked just the same.

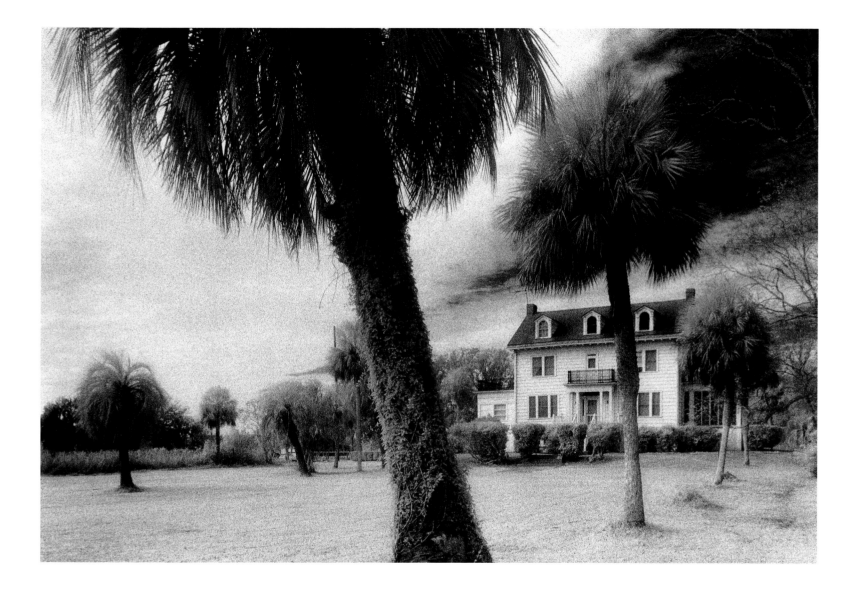

In the Dogwood Mobile Home Park in central Florida, many of the newer homes, by regulation, look exactly alike. You have to assert your individuality with shrubbery. That's a "poodle juniper" by the front door.

Gossip travels so fast here that, literally twenty minutes after I began photographing this house, my mother-in-law on the far side of the park was being told by an elderly neighbor, "George is selling his house! I know because there's someone from the realtor's out there taking pictures of it."

One day I came back from canoeing on the Withlacoochee ("Long and Winding River"), or possibly it was the Oklawaha ("Long and Winding River"), where I'd seen a large alligator stalking a small deer. I related this story excitedly to several assembled residents of the Park, all of whom had originally lived in the North and retired here to Florida. I had never seen an alligator in the wild before.

They were pretty excited too. "You saw a deer! How unusual!"

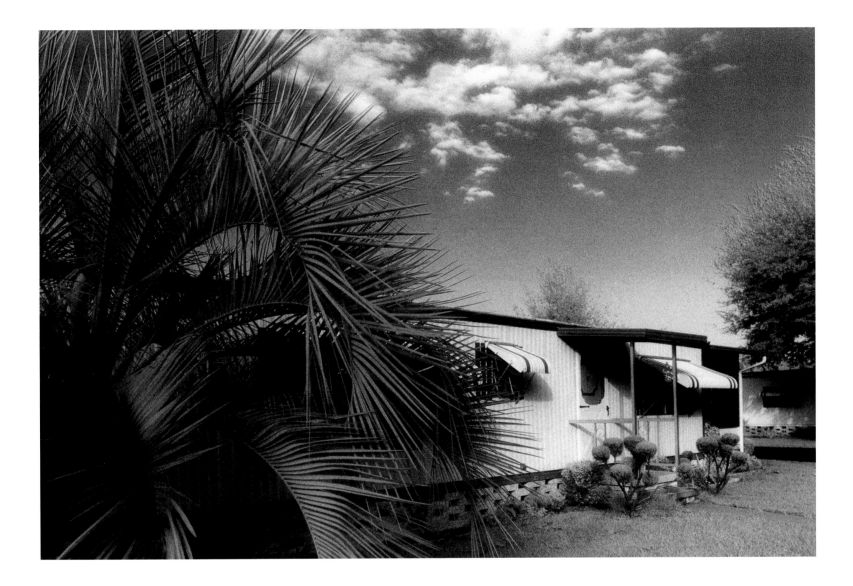

The languor of the drooping foliage and of the sleeping dog makes this place for me the quintessential Southern home. Mobile is a good-sized city with all the usual urban problems, yet while I was photographing here I encountered a most astonishing example of Southern hospitality, or maybe you'd call it naiveté.

I was sitting on the curb across from this house, re-loading my camera. Infrared film has to be loaded in the dark; I use a black changing bag. You put the camera and film in the bag and zip it closed, then insert your arms through the sleeves of the bag. Basically, you appear to be armless. My bicycle was leaning against a telephone pole so it probably looked as if I'd just had a dismembering accident of some sort.

A woman came out of a well-kept ranch house nearby, heading to her car in the driveway. We'd never seen each other before. "Are you all right?" she called anxiously. I assured her I was fine and explained what I was doing. "Would you like a drink of water?" I politely declined. "Well," she said, "I have to go out now, but the door's unlocked, so if you want to go in and get something from the fridge, please help yourself."

With that, she drove away.

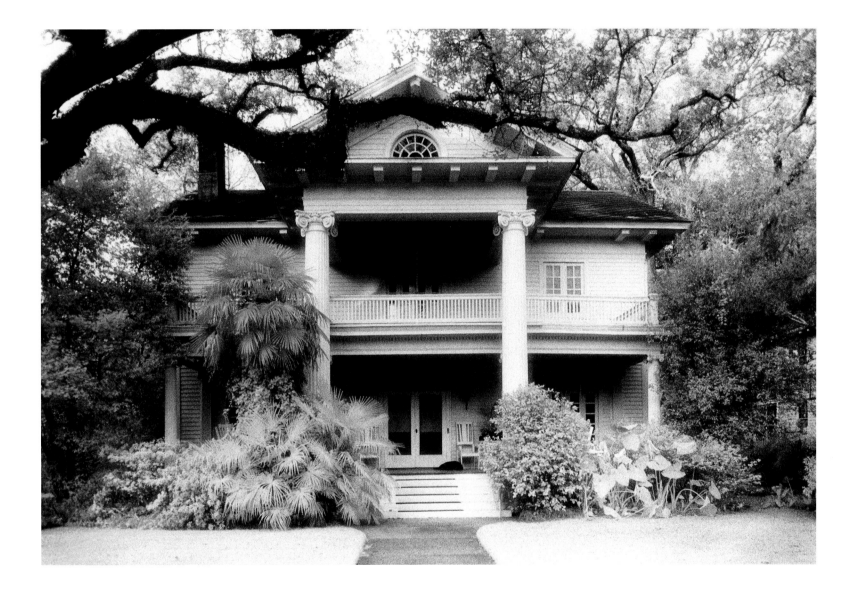

As you drive into Port Gibson, Mississippi, a big sign announces: "Port Gibson: 'Too beautiful to burn.' — General U. S. Grant, 1865."

On the Gulf Coast, Biloxi was also spared extremes of "Northern aggression," but a scourge of a different sort devastated the town a century later. "It was Hurricane Camille in 1969—that's why you see all the empty lots around," I was told by a man named Frank, who worked as a Yellow Cab driver in town.

This Stick-style folk Victorian house on Beach Boulevard, a bed-and-breakfast inn, has an elevated first floor common to the Gulf Coast (the better to survive the storm surge). The front steps were built around the palm tree.

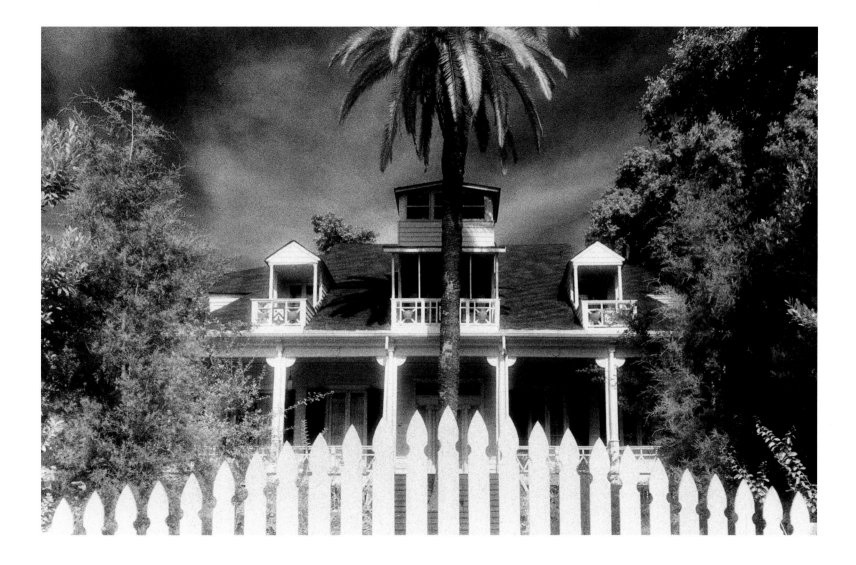

I reached New Orleans in the heat of the election for governor pitting former Ku Klux Klan leader David Duke against the incumbent. On TV one of the anti-Duke commercials showed an LSU supporter holding a football. He said, "Do you really think we can recruit the top athletes in the country with David Duke as governor? It's goodbye Tigers or goodbye David Duke." Duke was close in the polls; the election was in three days. A curator at the Contemporary Art Center told me, "This election has us all immobilized!" Five young black men hassled me on Bourbon Street, saying it was a good thing I wasn't voting for Duke, or they'd have to bash my head.

I stayed for two days, then drove out of there as far south as it's possible to go, eighty miles out a narrow causeway into the Gulf to the town of Grande Isle, where I simply turned around and drove back. Old houseboats, skiffs, and tugs lined Bayou LaFourche; kingfishers perched alertly on power lines.

Nearing Thibodaux, I saw handmade signs on every telephone pole for twenty poles, nicely lettered cards placed evenly each about twelve feet off the ground. The first one said, "Fried Catfish." Next, "Blackened Catfish." Next, "Softshell Crab." Next, "Crawfish Etouffée," . . . "Fried Crawfish" . . . "Crawfish Pie" . . . "Crawfish Filé Gumbo" . . . "Seafood Gumbo." Finally, the signs stopped and an arrow pointed to a tiny roadhouse: Boudreau's Restaurant. If it hadn't been nine o'clock in the morning, I would have pulled right in.

This house was built in 1987, its double-curving staircase modeled after that of the nearby antebellum estate, Evergreen. The owner told me I should have been there two weeks before, when the bayou had flooded the entire property. Her son had to paddle a little boat out to get the school bus, and her husband caught garfish off the porch.

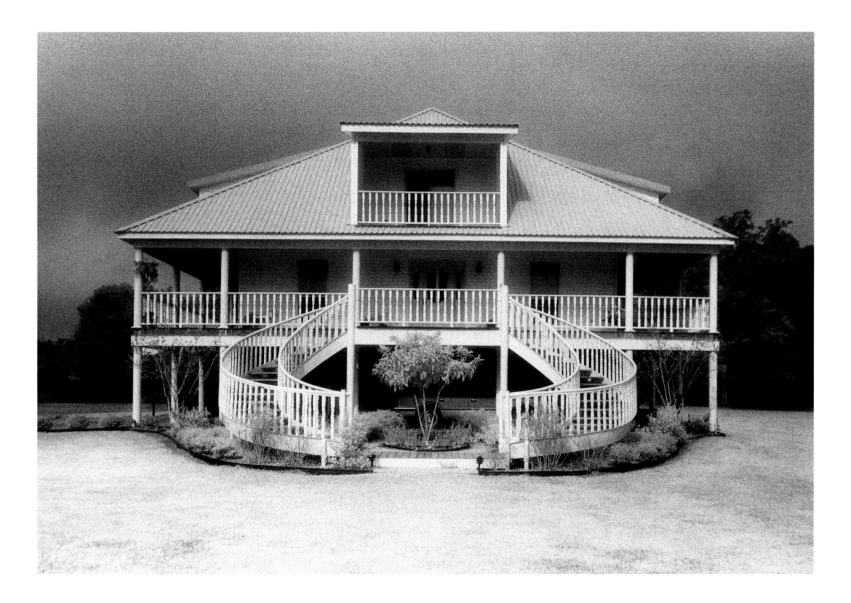

Heading south along the Mississippi from West Memphis, I was impressed with the fantastic dirt they have in that part of Arkansas. It was black; it looked loamy and ready for planting. It seemed impossible that this could be the second poorest state in America.

My motel in Pine Bluff was filled with displaced residents whose houses and trailers had been flooded out by the Arkansas River. The disaster lent the city another layer of despair, deeper than the peeling paint on its houses or the barren streets of its downtown.

When I was in high school, I used to write "Smackover, Arkansas" as my return address when I sent letters to my friends. Now I saw it on the map again and detoured into Smackover just so I could send some postcards from there. "Hey, I'm really in Smackover," I told those same friends, twenty-five years later.

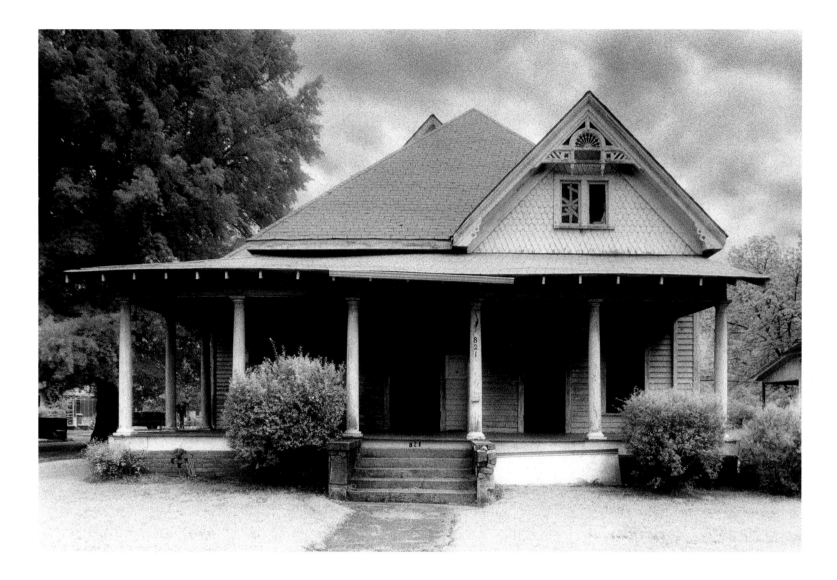

Entering the little town of Graniteville, you notice immediately that many of the houses and public buildings are pink. (Casting back ten years, my recollection is that the entire town was pink, but I know that can't be true.) They're built from the "Missouri Red" granite that has been quarried there since 1869. Graniteville granite is described in a University of Missouri abstract as "unique among Missouri granites due to its brick-red color, rapakivi texture, and presence of muscovite and rare mineral-bearing pegmatite (i.e., topaz)."

At nearby Elephant Rocks State Park, you can walk among giant, weathered boulders of Missouri Red, dating back to Precambrian times.

In a news item from 1996, I read that a Graniteville quarry was drained of 3 million gallons of water when a psychic insisted that the body of a missing girl was in there. The psychic was wrong.

I could hardly tear myself away from Gatlinburg. It isn't just that Cades Cove in Great Smoky Mountains National Park is stunning in the misty dawn. It's also the motels, the density and variety of which must be unparalleled anywhere else: over a hundred of them line the streets of this town of thirty-five hundred residents. From blaring billboards to quiet meadows, Dollywood to Gregory Bald, the bipolar spectacle of the region is perversely fascinating.

Finally, I had seen enough of my corndog-carrying fellow Americans (it's the most popular of our national parks), and I drove northeast to Jonesborough, marked in my guidebook as the oldest town in Tennessee. Jonesborough was founded in 1779 when all of present-day Tennessee was part of North Carolina. At some point the spelling became Jonesboro (maps from the 1940s show that); then in 1983 the townspeople restored the original "ugh." Likewise, Jonesborough's nineteenth-century character is preserved handsomely, in part because its village streets lie well off the actual main drag carrying most of the traffic on to Greeneville or Johnson City. Truly a fine place for a stroll.

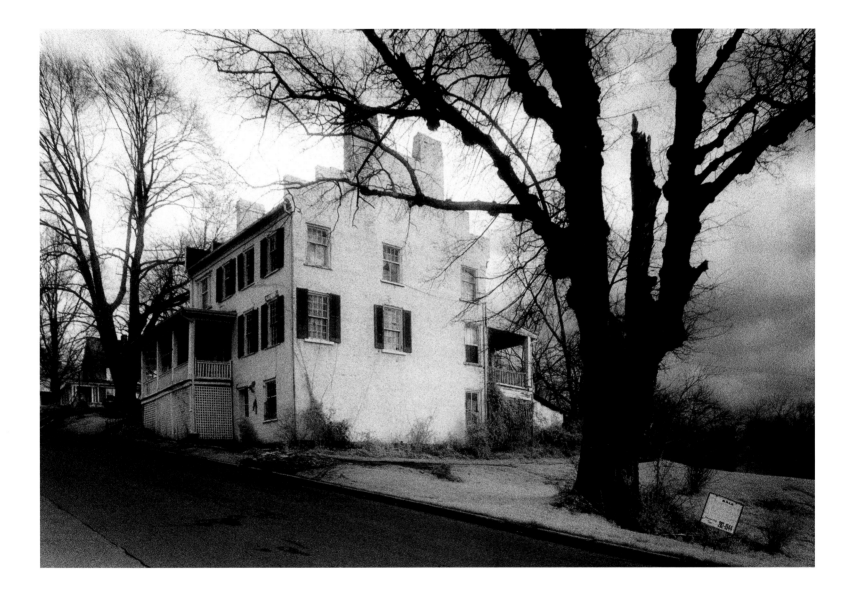

If you go to Kentucky Fried Chicken and you're actually in Kentucky, does it count as a local eatery? All right, it was exactly the same as the one at the end of my block in Philadelphia. So I atoned with a dinner at the Boone Tavern Hotel, which is owned and run by Berea College. The college is tuition-free for the mostly Appalachian students in exchange for work and craft production. The formal dining room was staffed by scores of timid undergraduates. My meal was sensational: leg of lamb with pecan dressing and mint sauce, beets and turnip greens, and my first-ever spoon bread, an eggy, moist, collapsing corn souffle, served with a big spoon. The next day I went to a crafts fair and bought a ceramic spoon-bread baker, complete with recipe.

I stayed in nearby Danville that night, at a motel run by friendly Sri Lankans and patronized by Confederate soldiers (a reenactment was going on nearby). On the road to Harrodsburg, I followed a pickup truck with two guys riding in the open back, both playing guitars. I pulled in to look at this antebellum house, knocking on a massive oak door. "It took three men to lift that thing," said the young owner, a former professional basketball player. He ran a sports trading card shop out of the house. ("Fleer!! Donruss!! Topps!! Score!!") I bought José Canseco for a friend back home who thinks he's cute.

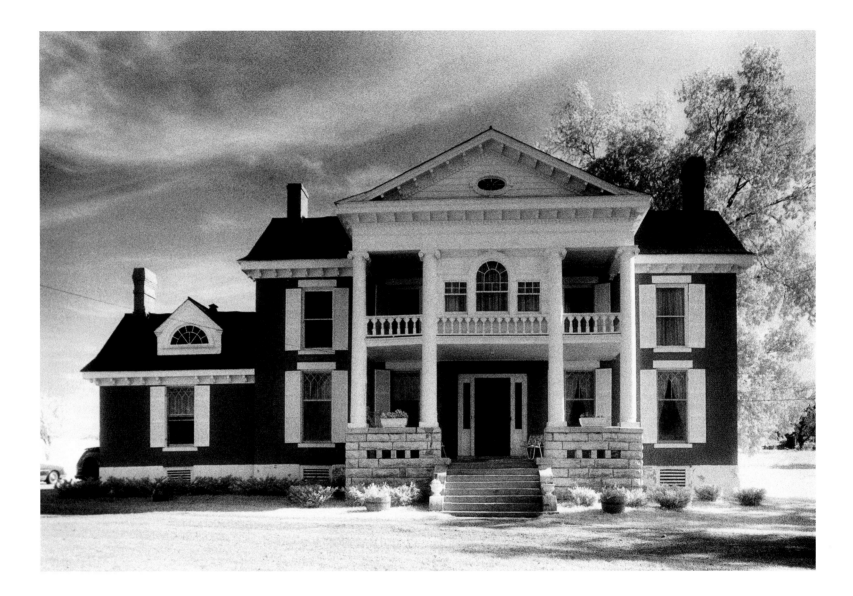

A sign near the door read "Beware of Fox." David Fox led me into his office (showing off a magnificent oak pool table as we passed) to conduct a formal interview, providing extensive detail about his place, down to how the woodwork (including nine walnut mantels) would be painstakingly restored (with Formby's Stripper and Tung Oil). He was remarkably gracious in his white terrycloth bathrobe, even though I'd wakened him by banging on the door.

The 1890 Page-Vawter House (as it is known) was in rehab limbo at the time of this photograph, but Fox had just received a grant from the governor for its restoration. It had been placed on the National Register of Historic Places in 1985. He explained:

"There are very few of this type left. In the 1870s, the C&O railroad ran through the New River Gorge, setting the stage for late industrialization. They started timbering and taking out coal. A labor force was needed; Eastern Europeans, Italians, Irish, and so on were coming into the U.S. It was almost a feudal society around here—the coal operators led a fabulous lifestyle, and the workers were like serfs, renting from them. Page ran the Golly Mountain operation and was relatively humanitarian."

Fox gave me generous run of the property, so I shot several rolls of film over the course of the morning as the fog lifted and the light changed.

Later that day I was riding my bike along the flat main drag of Ansted when a chubby boy waved to me and hollered across the road, "Watch out for them mountains!"

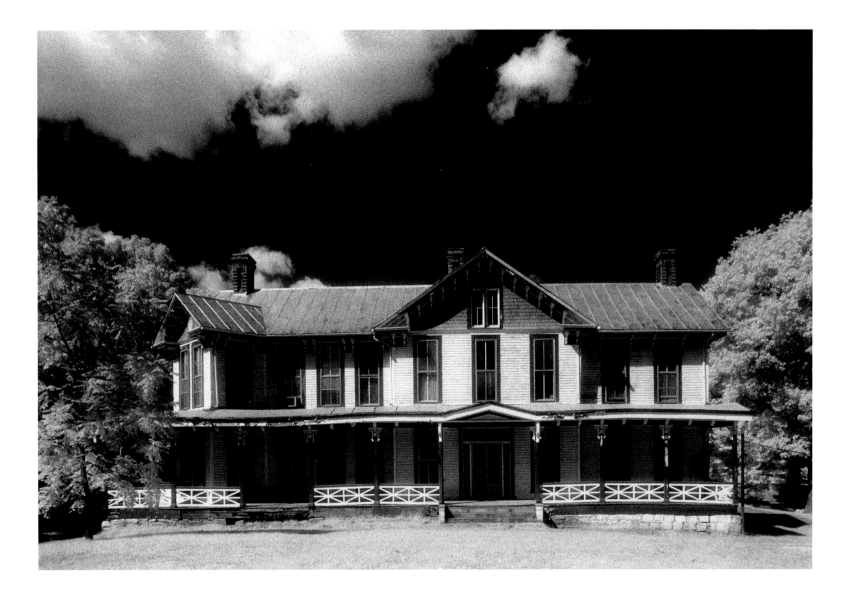

I first cruised Ohio during the presidential campaign/ World Series season of 1988. In my motels, with the curtains drawn, I could have been anywhere in America. When I turned on the TV and watched the debates or baseball games, I could only have been in America. When I yelled at Dan Quayle or the Dodgers, I felt connected to the rest of America.

Yet there are towns in Ohio with as strong a sense of place as any in the nation; some of them still have reasonably thriving Main Streets and well-preserved nineteenth-century brick buildings. You feel the West beginning here, in the wider streets, more monumental façades, and more open, spreading farmland. People paint their names on their barns or give up the space for "Chew Mail Pouch Tobacco" ads; they run roadside vegetable stands with honor boxes; they invite you into their homes to see their craft projects.

This Ohio house reminds me of a poem by Edward Hirsch, called "Edward Hopper and the House by the Railroad (1925)." It closes:

"This man will paint other abandoned mansions,
And faded cafeteria windows, and poorly lettered
Storefronts on the edges of small towns.
Always they will have this same expression,

The utterly naked look of someone
Being stared at, someone American and gawky,
Someone who is about to be left alone
Again, and can no longer stand it."

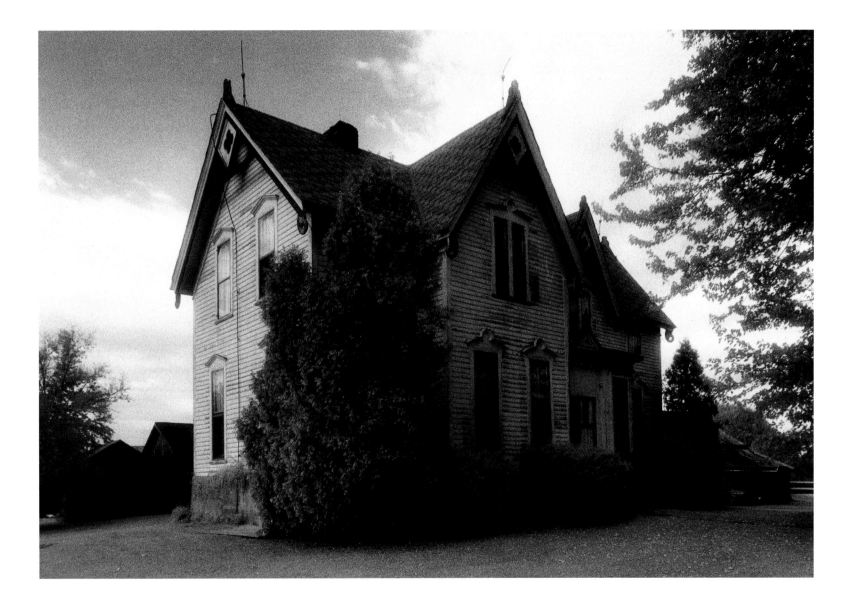

Sometimes, simply crossing over a state line brought a change in the way the houses looked. For instance, after passing from West Virginia into Kentucky, I started seeing brick ranchers adorned with neoclassical pediments, with and without porticos.

And moving north from there to Indiana, stately red brick Victorians appeared. Also, hostile signage started popping up at the entrances to farms. "This Property Protected by Farm Watch—No Trespassing." Whether there had been a crime wave in Indiana only, I don't know. But this farm was no exception, so when no one answered my knock, I backed off to the road and shot it from there.

Several years later I was driving in the area again and thought I'd swing by to see if the owners were around this time. They weren't, but an enormous American flag hung from the roof, obscuring most of the front of the house. It was the Fourth of July. The picnic must have been somewhere else.

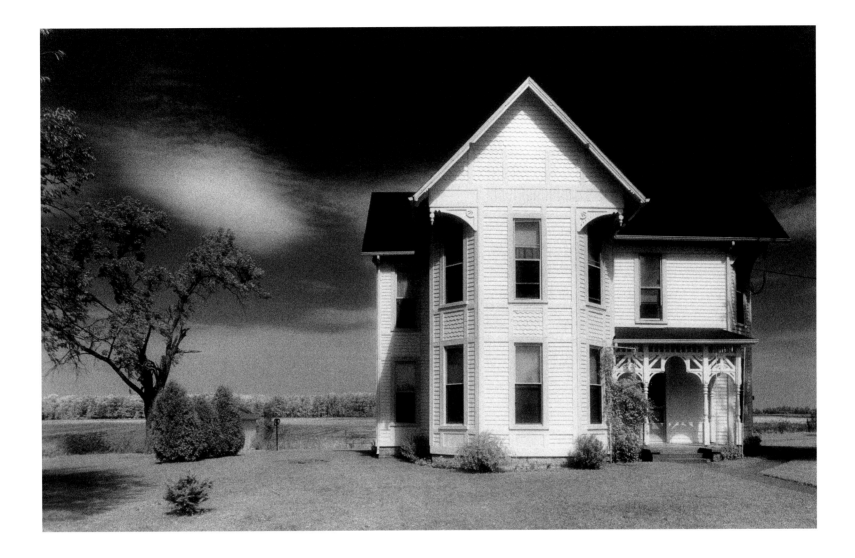

Three hundred miles north of Detroit, I passed over the forty-fifth parallel, exactly halfway between the Equator and the North Pole. In late November, it felt a lot closer to the Pole. At the tree line (where the fir trees start; south of that, the land has been farmed), the snow cover began.

I crossed the five-mile bridge to the U. P. (Upper Peninsula, Unending Precipitation) and headed for the boat to Mackinac. One ferry terminal in Saint Ignace displayed this sign: "Closed. Reason Freezen. Hopen Open April 30." Luckily, Arnold's ferry service was still running for the benefit of the few year-round residents of the six-square-mile island. Early the next morning, I boarded with my bicycle, the only vehicle you are allowed to bring.

Mackinac Island is heaven for houses. Not only is the place sprinkled with gorgeous Gothic and Victorian summer cottages, but there are no cars or power lines to get between them and the camera. Residents and tourists alike walk or ride bikes; there are horse-drawn wagons to carry baggage. According to AAA, the road circling the island, SR 185, may be the only state highway in the nation on which a motor vehicle accident has never occurred. In summer the town and the bike paths are swarming with tourists, but on this cold, drizzly day before Thanksgiving, I seemed to be the only visitor out there. To my disappointment, all the fudge shops were closed.

When I saw this cottage, I was so sure it was going to be the Michigan house I shot more than forty frames of the same composition. That's Lake Huron and the Straits of Mackinac visible through the opening where the road comes through.

Later I waited on Main Street for the last ferry and watched as all the day workers, big men in construction gear among them, tore into town on their dinky little bikes and left them in a massive pile outside the bar. One quick drink for the road; a six-pack for the boat. It's a holiday weekend.

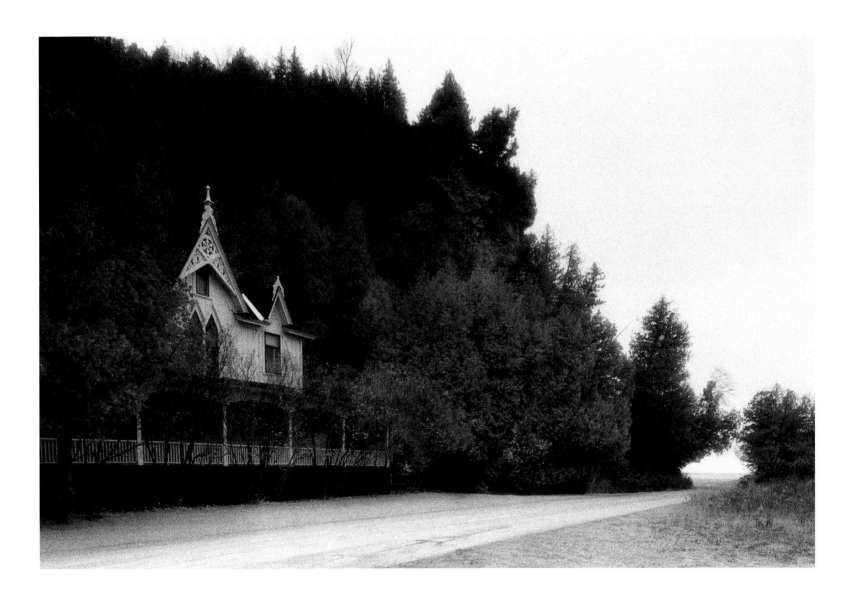

Frank Lloyd Wright's home and studio is in this well-kept suburb of Chicago (what they now call an "inner-ring" suburb), and the neighborhood is rich with Wright houses, twenty-five of them. Clots of art students dressed entirely in black or vacationing couples clutching their maps stand staring at the houses.

I toured the place on Chicago Avenue where Wright lived and worked from 1889 to 1909, developing his Prairie style of architecture. I felt a little claustrophobic, as I did in Wright's Pennsylvania masterpiece, Fallingwater. He claimed that his low ceilings and horizontal lines forced one's gaze outward to the landscape, thereby bringing the outside in, but it wasn't working for me. You can't even see the sky from in there.

Give me a three-story Victorian with soaring ceilings and oversized vertical windows, with a nice porch to sit out on, and I'll show you a house that brings the outside in.

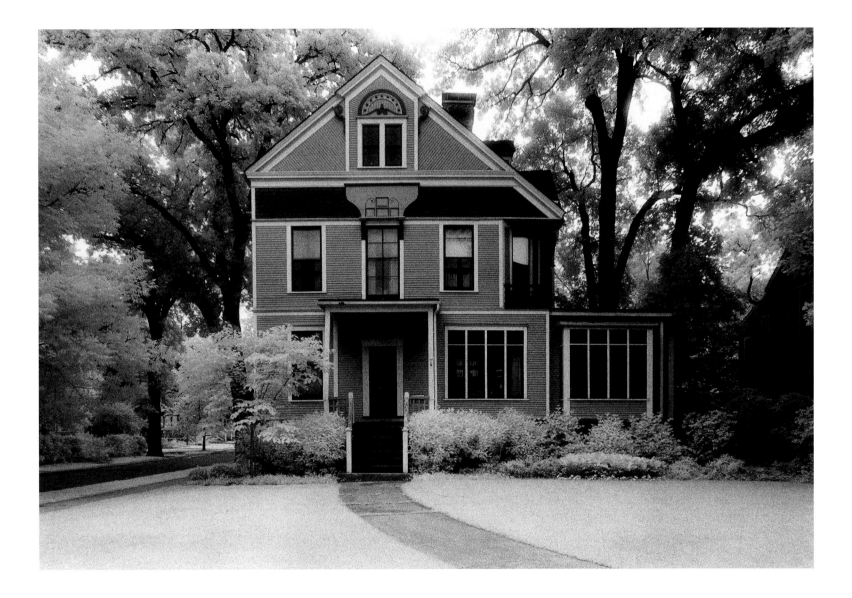

Crossing the Saint Croix into Wisconsin, the autumn foliage was mauve, maroon, russet, and dark gold. There was little of the scarlet brilliance of New England. The hills rolled along as gently as the colors, so the back roads were perfect for bicycling. I passed through Siren, Spooner, Rice Lake, Menomonie, Osseo, and Hixton. In Spring Green, I wolfed down the best coconut cream pie on the planet, in a restaurant designed by Frank Lloyd Wright.

In Black River Falls, I bought some stuff at an antique store: a little canoe-shaped basket woven from strips of bark and a Swedish "Eric-o-phone" telephone for my Swedophilic brother whose name is Eric. Black River Falls is the locale of Michael Lesy's 1973 cult classic book *Wisconsin Death Trip,* a compendium of turn-of-the-century studio photographs and regional news clippings, largely detailing peculiar crimes and deaths. Reading the book, you get the feeling that this is a really creepy place.

Odd, but when I returned here five years after making this photograph, I looked carefully for this house and couldn't find it again. I think it was simply unrecognizable in a different light.

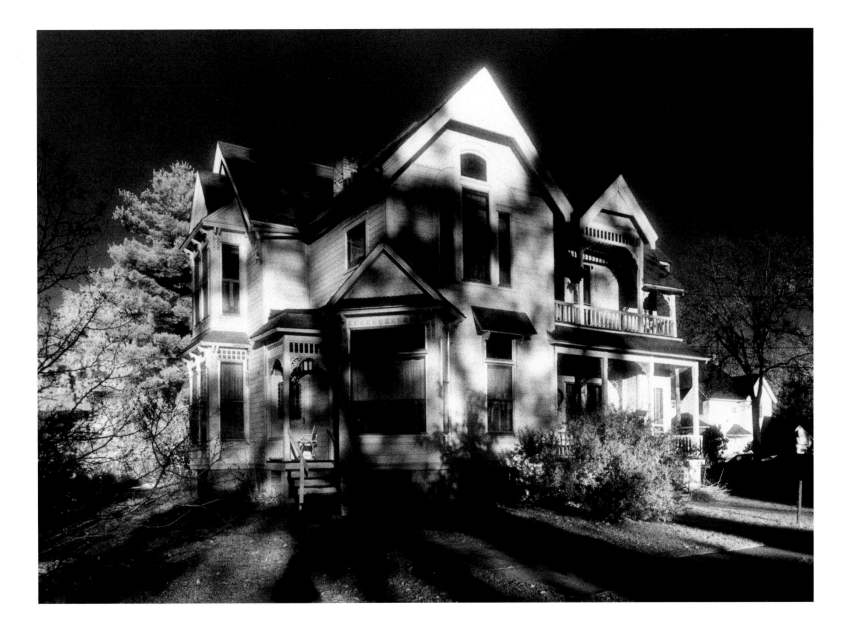

This is my father's boyhood home. He talks about it often: about the wonderful rooms he and his brothers played in, about the makeshift tennis court on the side lawn and the toboggan run out onto the frozen Mississippi, about the family's famous electric car (the first in town), and mostly about his grandfather, Nehemiah Parker Clarke, a renowned lumberman and stock breeder who built the place in 1892.

I didn't visit Saint Cloud until I was thirty-five years old. I knocked on the door of the house unannounced, surprising the owners, who were unaware of my family's history there. In fact, they didn't believe me at first. Then they took me inside; it was immaculately maintained and decorated, with magazines fanned out on the parlor table as if awaiting the *House Beautiful* photographer.

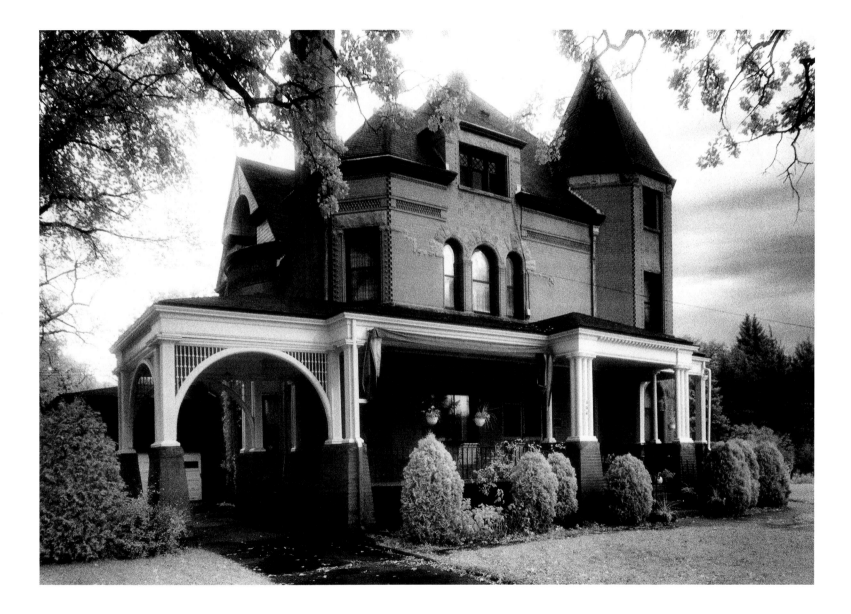

The farmer here told me that this house used to have a big porch all around it. It was rotted away by the deep snow they get in eastern Iowa. We talked about the climate, and I complained about how we used to get deep snow in Pennsylvania but not so much anymore, which I attributed to global warming.

"Aw, I wouldn't worry about that!" the farmer scoffed with a gap-toothed smile.

Looking around at the pristine, rolling green cornfields and clear blue sky, I could see how he wouldn't.

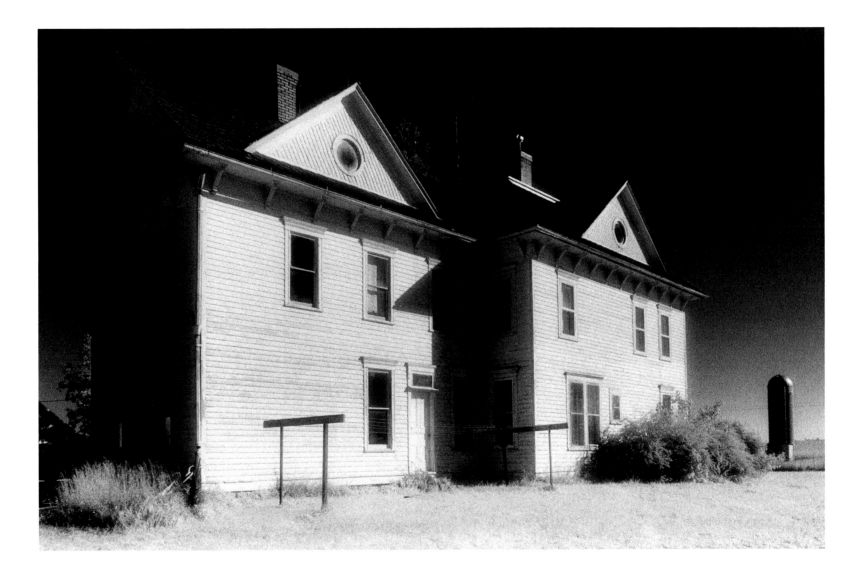

Observed: the following predominant road kill, various states:

Maine: porcupines
Pennsylvania: deer
Illinois: cats
Kansas: turtles
Missouri: small birds
Arkansas: armadillos
Texas: snakes, big dogs

Live birds sighted around Fredericksburg: northern mockingbirds, painted buntings, belted kingfishers, mourning doves, scissor-tailed flycatchers, black vultures, and, in one meadow, cattle egrets, five to a cow.

Fredericksburg was settled by German farmers starting in 1846, and the many well-restored structures in the area reflect the German influence. Blocks of chiseled pink, peach, or yellow limestone commonly make up these houses. West of town, Highway 10 is blasted through the hill country, creating half-buttes or crested walls of that same limestone.

This limestone cottage (not one of the sixty bed-and-breakfasts listed on the Fredericksburg website) bears the historical name of the Peter-Schmidt-Treib-Langehening House. Mr. Peter, a stonemason, built it on a lot he purchased in 1853 for sixty-five dollars.

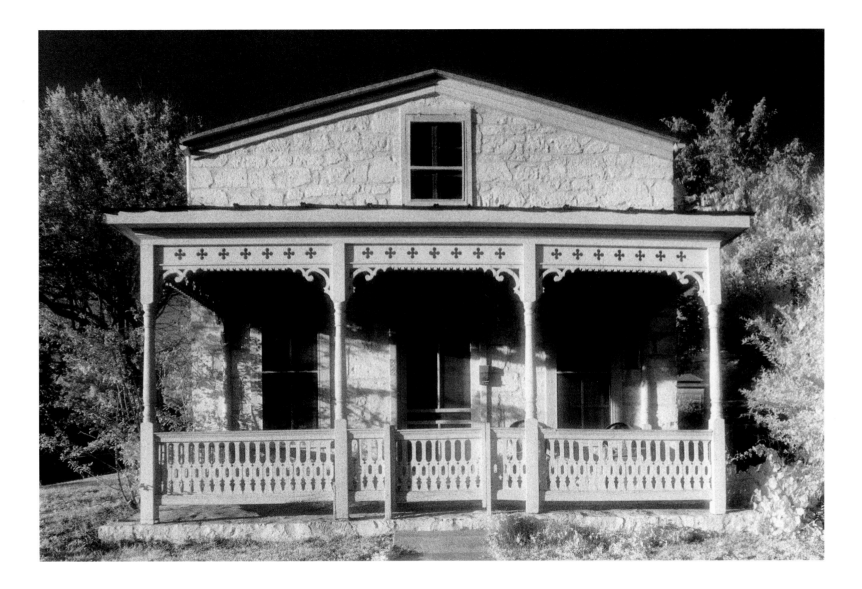

My first husband's favorite bird was the kingfisher, so when my map showed Route 3 passing through a place called Kingfisher, I was more fixated on obtaining memorabilia from the area than on locating a suitable house for a portrait. Besides, I was sure that Guthrie, thirty miles ahead and possessed of a renowned historic district, would yield the houses I needed. But first I paused in downtown Kingfisher at the Chamber of Commerce to see if they had any matchbooks with kingfishers on them. No such luck. No matchbooks, no T-shirts, no shot glasses—what kind of tourist trap was this, anyway?

Not any kind. Kingfisher's just a medium-sized plains town surrounded by farms and ranches, both working and abandoned. So it was appropriate that the only kingfisher I saw there (and photographed in color to take home) was the big blue one painted up high on a grain elevator on the edge of town.

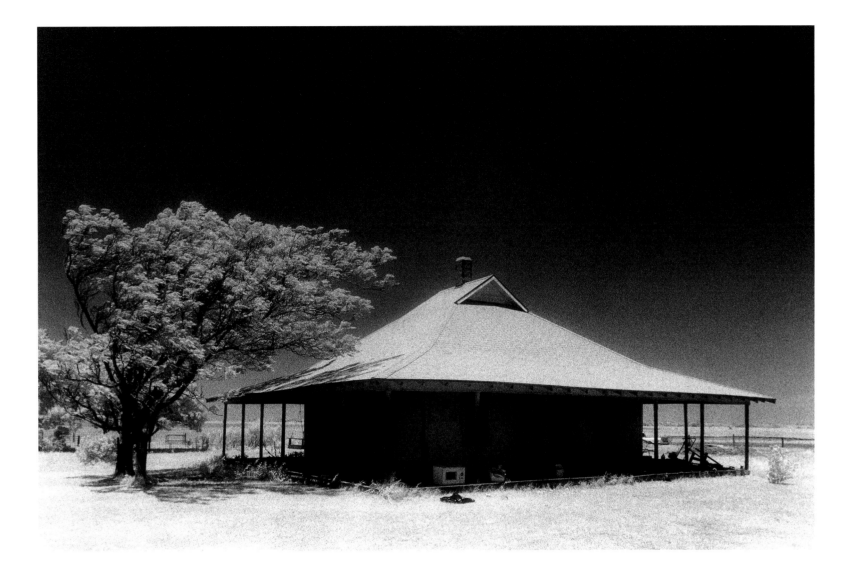

In Marysville, about as far as you can get from the ocean in America, the Best Western is called the Surf Motel. The clerk couldn't tell me why. I should have known myself—the Honda had taken every rolling rise of windswept U.S. Highway 36 like a dory in the swells off Cape Cod. Off the road, I'd walked in the Sandhills of Nebraska and the Flint Hills of Kansas (not far from this house) and had seen patterns whipping through the grasslands as changeable as any waves. Here, the horse looks out from his pasture unaware of his role (minor as it is compared to the plow and the steer) as a destroyer of prairie, the tallgrass, shortgrass, and mixed-grass meadows that once covered much of America from Pennsylvania to the Rockies. Now it's like the ocean was pumped out and left as shallow and tame as the Great Salt Lake.

"As I looked about me I felt that the grass was the country, as the water is the sea. The red of the grass made all the great prairie the colour of wine-stains, or of certain seaweeds when they are first washed up. And there was so much motion in it; the whole country seemed, somehow, to be running."
 —Willa Cather, *My Ántonia* (1918)

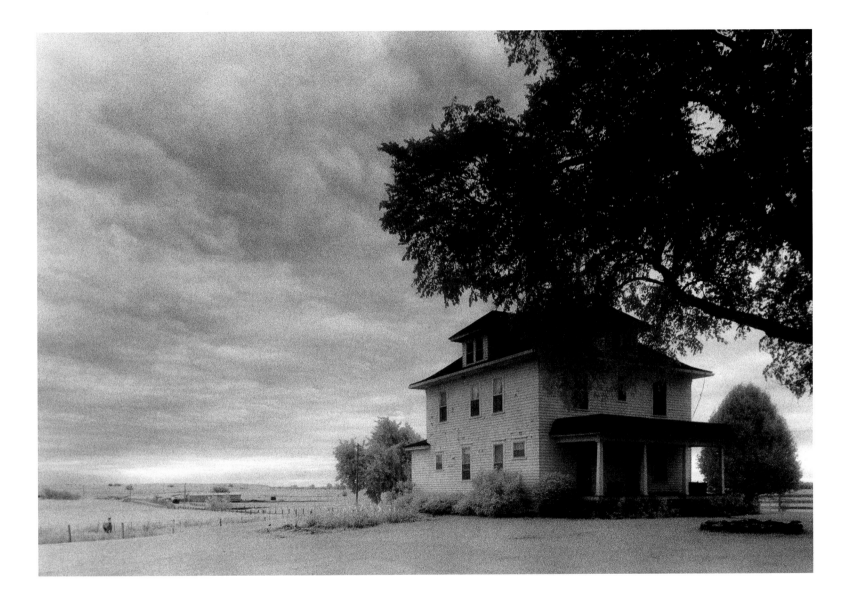

Owner Tay Schuff writes:

"This Lincoln County house was built in 1916–17. My father purchased the farm in 1958 and I moved in here in 1965. At that time we . . . put in forced air heat, a bathroom with a shower, and replaced some of the windows. In 1981 I started to remodel the house using woodwork from the house in which my father was born in 1901. In 1988 we made the first addition . . . the wing to the east with the front porch. In 1989 we added the wing to the west and in 1990 completed it with the patio.

"The barn was the original 'White Elephant Livery Stable' built in North Platte in the 1860s. It was moved to Sutherland around the turn of the century. By the 1920s livery stables were no longer needed and it was moved the six miles to its present location.

"The farm and house are located on the original Lincoln Highway—the first coast-to-coast highway, from New York to San Francisco. The house was called 'Half Way House' because it was halfway between

Paxton & Sutherland (the two neighboring towns)
North Platte & Ogallala
Omaha & Denver
San Francisco & New York."

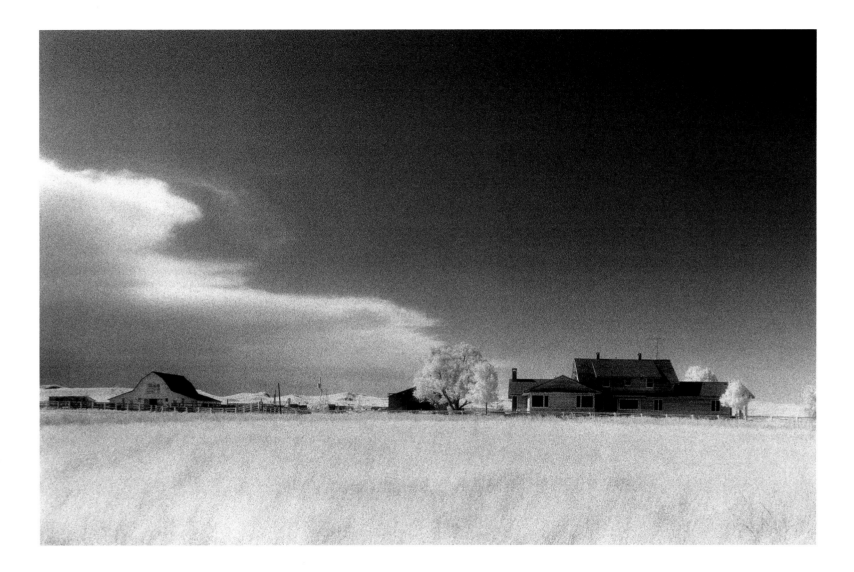

Just outside of Badlands National Park, Interior is a motley plains town avoided by the vast majority of travelers to the park. Too bad for them; there's a café there which has better food than the Visitor Center and a lot more local color.

Local color: night lightning crackling white, blue, yellow, and pink, spread out in veils across a panoramic sky.

Local color: black-tailed prairie dogs, black-billed magpies, black-footed ferrets. These are the only native American ferrets; now reintroduced into Badlands, in 1987 there were just eighteen left in the world. *Pispiza etopta sapa,* say the Lakota, meaning "black-faced ground dog."

Local color: mud, gray mocha mud, the most tenacious mud imaginable. After a hike the morning after a storm, it took twenty minutes of vigorous chopping with a screwdriver to remove the dried gunk from the treads of my boots.

Local color: the paint that peels and flakes from abandoned farmhouses all over the Northern Plains.

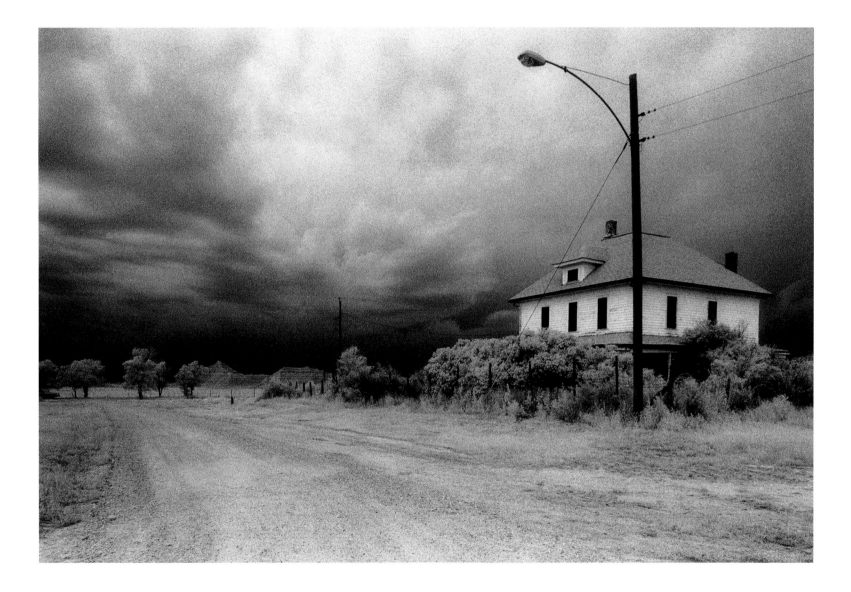

From a poster promoting the Homestead Act of 1862:

"Homes in the West
The Free Lands of Dakota
The Territory of Dakota contains the most
DESIRABLE GOVERNMENT LANDS for the purpose of AGRICULTURE . . . the **Homestead and Pre-Emption Laws** confer upon Every Citizen of the United States . . . and also upon women who are the heads of families, widows and single women as well as men who are above age; orphans who receive no support from guardians, and even minors who have 14 days in the army the right to **320 Acres of Land!** or 160 acres as a pre-emption . . . being a **Free Gift from the Government** to the actual settler. Millions of acres of **FREE LANDS** are still unoccupied; lying in the great valley of the Missouri river and its many tributaries in Dakota offering to the poor and industrious of every Nation and clime
A HOME AND ULTIMATELY A FORTUNE!
Dakota is a new country . . .
Its Lands are of the best Quality!"

Unfortunately, plots of only 160 or 320 acres proved to be tragically inadequate for a part of the country that regularly suffers bad seasons of drought, wind, and cold. Easterners and Europeans ditched everything to go West seeking autonomy and prosperity on the plains. Instead, they ended up abandoning their new homesteads in droves. Today the Great Plains from Texas to Montana are littered with deserted farmhouses. They are the region's defining architectural legacy.

I photographed many of the abandoned places (see Oklahoma and South Dakota), but finally it was bracing to see someone trying to make a go of it in the late twentieth century.

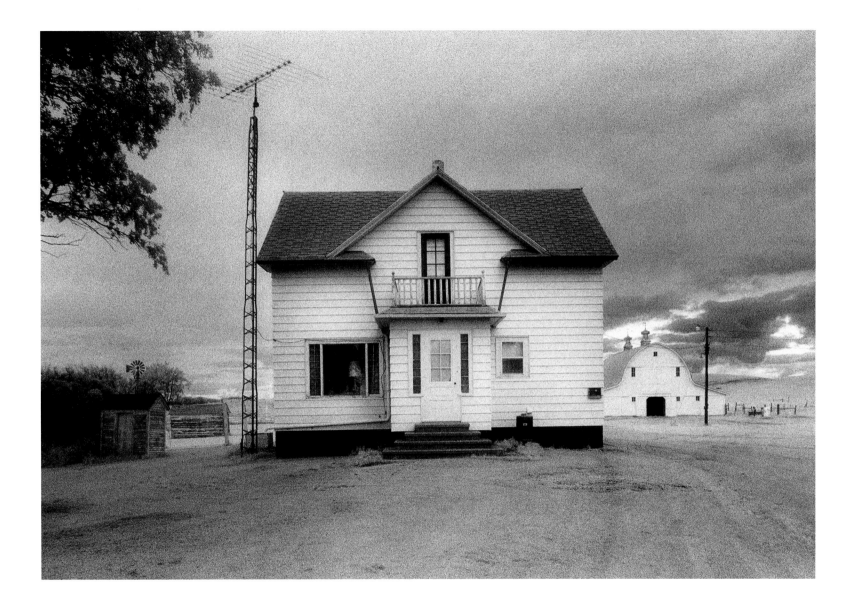

I headed north from Helena, the capital. Somewhere in the middle of the wind-whipped open plains, before you get to the Divide where the peaks of Glacier Park dominate, there's an isolated community called Heart Butte. I could see a strange homemade building up on a hill, so I went to investigate.

There a brother and sister, maybe ten and eight, ran out to greet the car like it was Santa's sleigh. But they were bringing me something. "Would you like to hold our cat?" cried the boy, whose name was Irvin John "Rooster" Spotted Bear. He thrust their enormous, long-suffering pet through the open car window. I stroked and admired her, and then Rooster and Carleen showed me their grandfather's art studio, the building I had seen. They stood by as I shot it, and then they wanted to be photographed and to photograph me holding the cat. Rooster had a steady hand, as the pictures I sent them later showed.

The photograph of the studio wasn't bad either, but I knew I wouldn't use it because it wasn't a house, strictly speaking. I kept looking. Across the Divide, I came to a halt at the sight of this false-front house, an anomaly. Usually, only commercial buildings sport these façades. The entirety of downtown Rollins, a store/café/post office in a small frame building (sans false front), sits across the dirt parking lot. The storekeeper explained that the house had been built only twenty years before, but the timbers were "original." The owners were actually from the Philadelphia suburbs, ten miles from where I'd grown up. Was this an Easterner's idea of a Western house? My friends in Missoula were disappointed when I told them this was the house I picked. "There are so many fine Victorian mansions in Montana," one of them said.

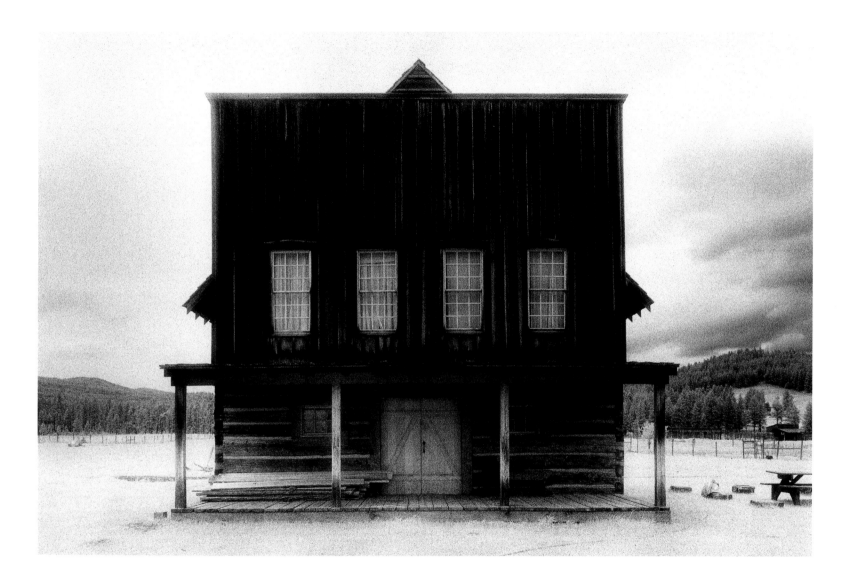

I saw some amazing things in Wyoming. The 867-foot monolith Devil's Tower was so compelling, it was as if it were lodestone and we visitors were made of steel. I also saw, in Buffalo, the state's largest outdoor swimming pool. It was mind-boggling; two and a half Olympic pools could fit in it. I also saw a baby moose clomping through the cottonwoods at dusk with the snowcapped Tetons towering in the background.

I also saw a sign outside a store that read:

"Western Clothing—Indian Relics—Jewelry—Fossils—Antique's [*sic*]—Fax—Dolls—Minerals—Rocks—Boots—Crafts—Cappuccino—Gifts—Books—Bibles—Art—Hats—Tack—Shipping—Deli—Boutique"

The architecture of the Western plains can be as eclectic as that list of attractions—there's no shortage of homes made out of Quonset huts, for example. But this picture represents to me the possibility that even new construction (the house wasn't quite finished) can respect a regional building tradition and adapt to the lay of the land.

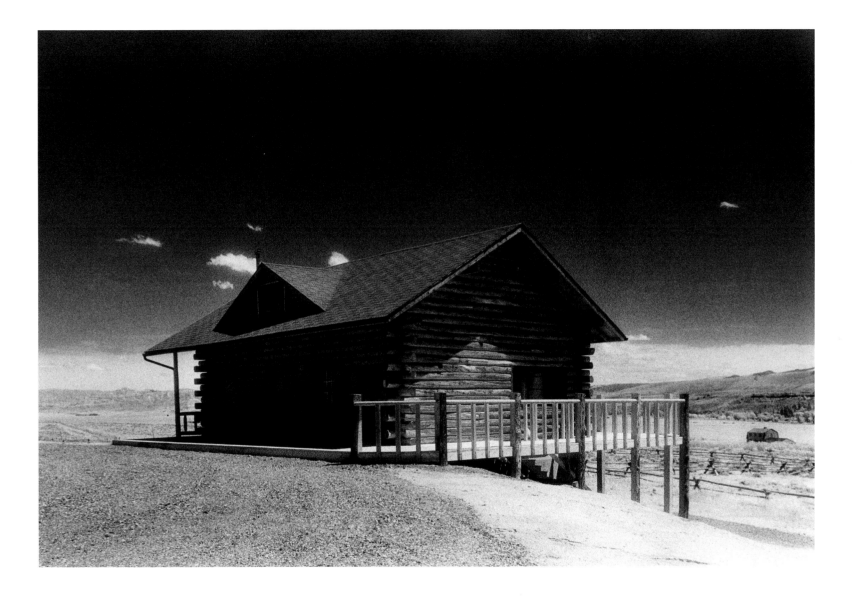

A booklet from the Utah Heritage Foundation called "Historic Buildings along South Temple Street" (the first residential street in Utah) describes this house as follows:

"The George M. Downey home [built in 1893] is a local restoration showpiece. . . . In the early 1970's, it was an apartment house of no discernible style, painted bright red and green. . . . Removal of old paint by the application of a caustic solution was followed by a washing process, then sanding with a hand-held belt sander. What emerged from this careful work was an attractive Shingle style house with a round turret, segmental bays and a broad gable, constructed of buff-colored brick and natural shingles applied in imaginative designs."

Unfortunately, it had submerged again by the time I wandered along in 1994. Scaffolding covered the front of the house, so I composed my picture from the side with a strategic placement of shrubbery.

Salt Lake's downtown streets are so wide (up to 128 feet) and the blocks so long (some encompassing ten acres) that pedestrians have a hard time crossing to the other side. In 2000, Mayor Rocky Anderson ordered baskets of Day-Glo orange flags to be placed at strategic points along the sidewalk. Crossers carry the flags with them, alerting drivers to their presence. "The streets are completely out of any human scale," said the mayor.

When Brigham Young laid out the city in 1847, the story goes, he wanted the streets to be wide enough to turn a wagon around.

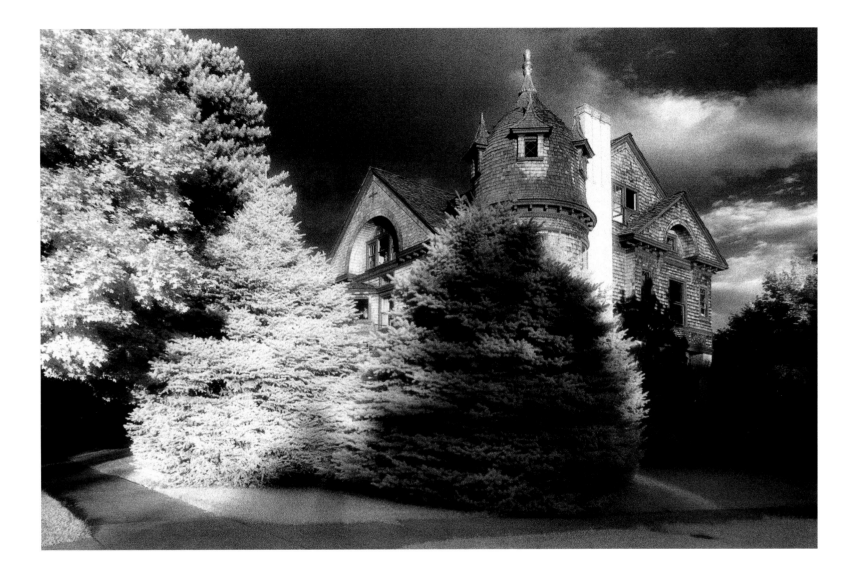

It was my fortieth birthday and, as I crossed Colorado heading east, for mile after mile the signs kept flashing 40—40—40. All right already! I happened to be on U.S. 40, the first interstate highway, the two-lane National Road, as it was first known. There were few cars on the plains east of the Divide; then I saw one coming up fast in my rearview mirror. It passed, slowed down, and settled in front of me. There were two men in the car. I passed, left them behind, and then it happened again.

If it came to that, I had the means to defend myself, a jumbo canister of pepper spray, purchased a week before to stun grizzlies in Glacier Park. The mere fact that this weapon was on the seat beside me made me jumpy. The threatening car pulled in to the same gas station I did, but since it was the only station for fifty miles that may not have been significant. I left before they did and never saw them again.

Knocking on the door of a strange house with wagon-wheel fencing seemed much less threatening, I don't know why. A man drove up in his pickup just as I got there, and his enormous English sheepdog raced across the field and knocked me over with glee. The rancher and I stood in the field talking pleasantly for a few minutes as the light waned. That night I threw the pepper spray away.

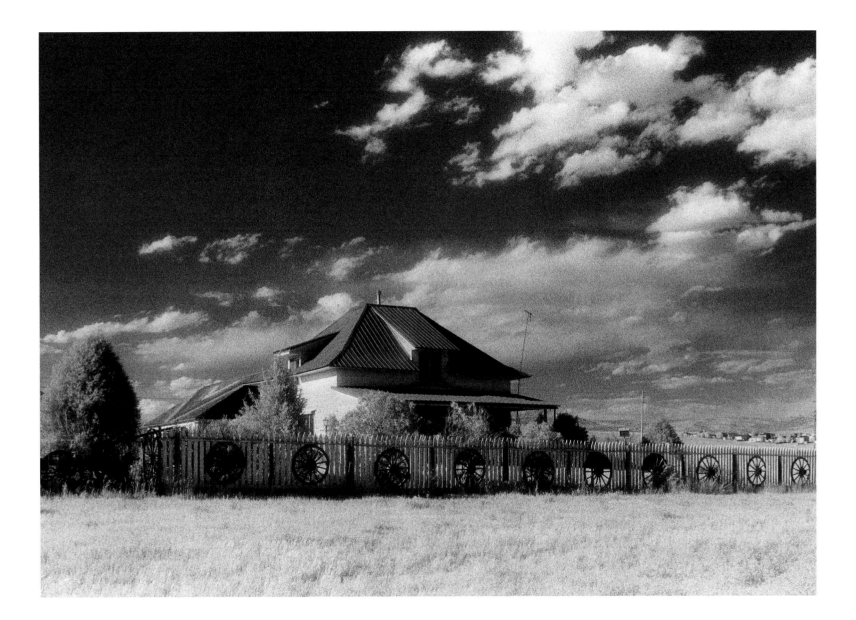

The friend I stayed with in Santa Fe worked as a waiter at the Pink Adobe, the hippest restaurant in town at the time. Local couple Sam Shepard and Jessica Lange went there. All the waiters wore pink Oxford-cloth shirts. Adobe is Santa Fe, Santa Fe is adobe, and everyone who sees this picture can tell me where it is.

From *A Field Guide to American Houses* by Virginia and Lee McAlester:

"Adobe walls are unusually susceptible to deterioration; if the roofs are not continually repaired, rainwater literally melts them into a formless mass of mud. As a general rule, adobe buildings abandoned for more than twenty-five years are beyond repair. Because most Spanish Colonial houses had adobe walls, the only survivors are those that have had continuous care. Regrettably, many of the most authentic examples were abandoned just during the past [fifty] years in favor of frame dwellings. This is particularly true in rural New Mexico, where irreplaceable examples have been, and are being, lost."

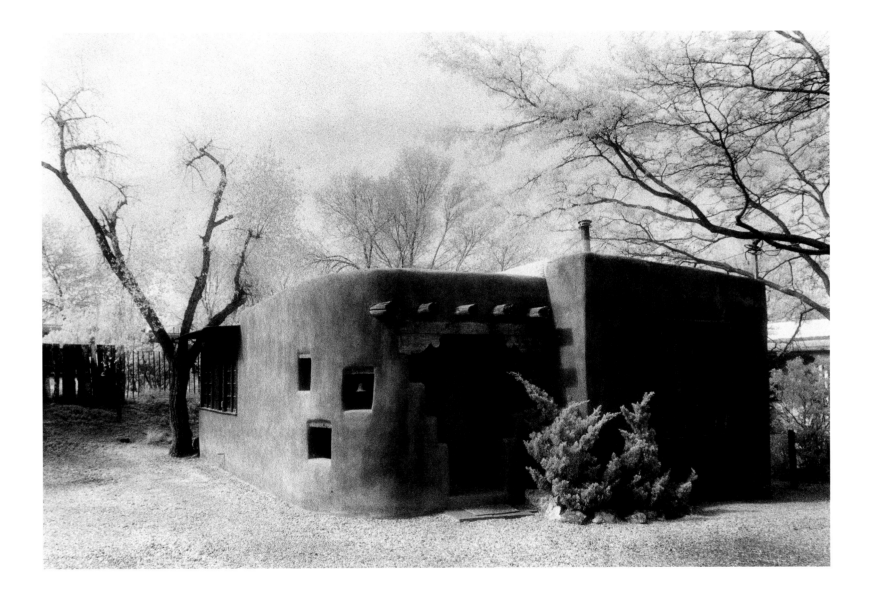

I heard tales of gunplay out here in the Old Pueblo. People shoot at the stately, humanoid saguaro cacti, shoot them full of holes and kill them. (Once, a man fired at a saguaro with a shotgun, and it fell over and killed *him*.) A friend of mine, a Tucson emergency room physician, shot three large rattlesnakes on his back stoop, at different times. Then he froze them for posterity. When I visited, he pulled the snakes out of the kitchen freezer as his wife grimaced, and then he displayed them on a backyard bench, stiff and coiled in prestrike positions.

Although the saguaro is to many a symbol of the entire Southwest and its bloom is the state flower of Arizona, it grows only in the relatively small portion of southern Arizona and northern Mexico covered by the Sonoran Desert.

It is a felony to shoot a saguaro. Fourteen of the seventeen types of Arizona rattlesnakes have no such protection.

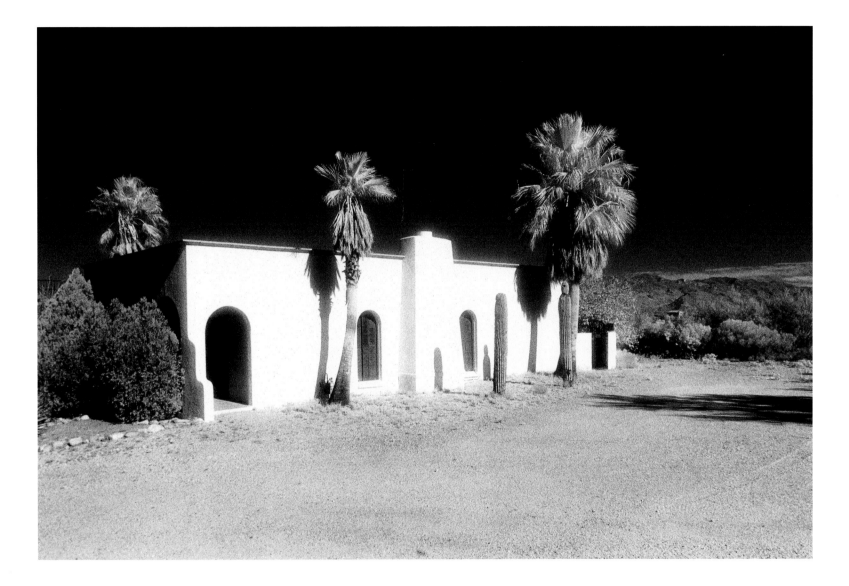

I have never driven my own car in California. Though I've driven through all fifty states, I have never crossed the entire country in one trip. When I finally get to do it, I'll take U.S. 50—Ocean City, Maryland, to San Francisco. The short stretches of Route 50 I have traveled are fantastic, especially the West Virginia portion.

I did manage to cover a lot of California ground, however, flying out three times and cruising first north and then south in various objectionable rental cars with bad stereos. I stayed in the wonderful towns of Murphys and Nevada City in the gold hills, and later I punctuated a visit to Santa Barbara with a boat trip out to Anacapa Island (completely houseless). Much later, I explored San Diego and picturesque Oceanside.

There is no choosing a "typical" California house when northern and southern seem like separate countries. Suffice it to say that the Mission Hills neighborhood was full of delightful little Spanish houses like this one, reflecting a style that was popularized at the 1915 California-Pacific Exposition in San Diego and that peaked in the 1930s.

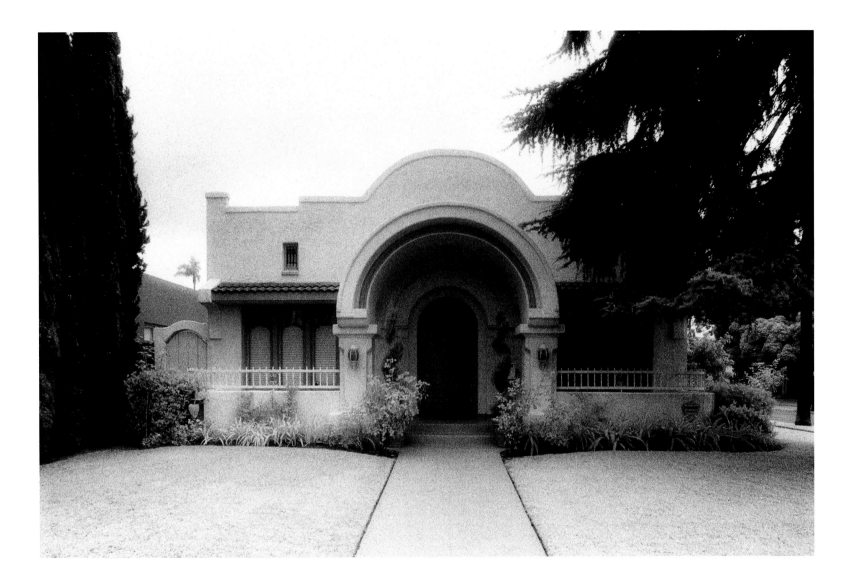

My attraction to this house was probably spurred by the same perversity that led me to Las Vegas in the first place. Like architect Robert Venturi (who wrote the seminal *Learning from Las Vegas* with Denise Scott Brown and Steven Izenour), part of me loves the outré, the tacky, and the garish—more so if somehow it can retain an element of grace. At night, the lights and faux monuments on the Strip are boldly gorgeous on their own terms. The zigzag roof on this house makes it wonderful, even if the whole situation describes much that is wrong with America's built environment. The driveway dominates the approach, the garage takes up much of the façade, and the hedge hides the house from us and protects the residents from having to look at their own vast pavement.

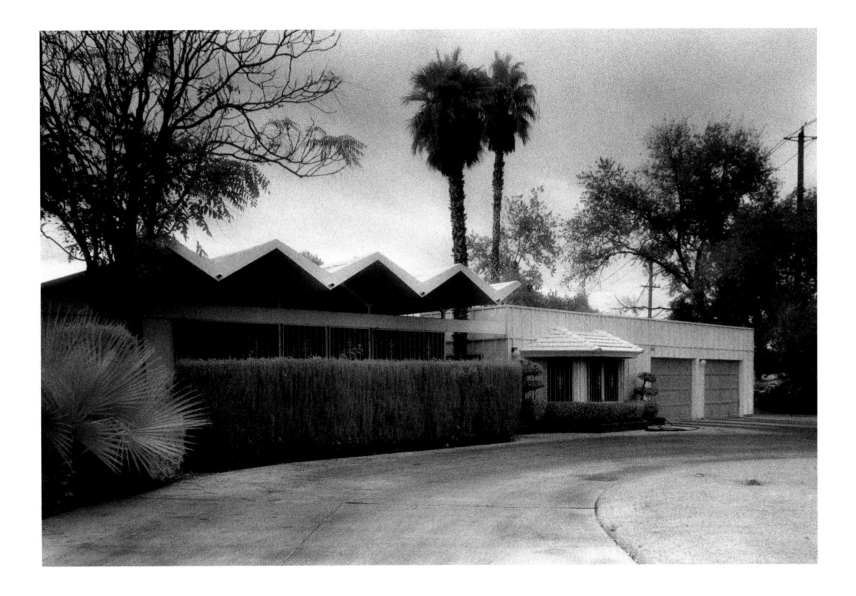

A breathtaking drive it was, winding southward on Route 93, following the Salmon River through sunlit, red rock gorges, scarcely another vehicle in sight. I stopped to visit a colony of cave houses, first inhabited by "Dugout" Dick Zimmerman in 1948. The caves were scooped out of a precipitous hillside and fortified with a hodgepodge of scrap materials: corrugated tin awnings, tire fences, driftwood entranceways. The area seemed nearly deserted, but Dick was there, telling me that he'd once been invited to the *Johnny Carson Show* to discuss his caves, but he didn't want to fly to California. (He likes Greyhound.) I was sure that one of these primitive dwellings would become my Idaho house, until I ran into another denizen of the colony, who smelled of whiskey and asked me where I was from. "Philadelphia? Ain't it, you know, kind of dark around there in the daytime?" With that, the appeal of the place was shot to hell for me.

In Warm River, I photographed this guesthouse of Three Rivers Ranch and chose it to represent Idaho. The next year, I bought a wonderful book called *Our Smallest Towns,* by Dennis Kitchen. He'd photographed the residents of the smallest town in each of the fifty states. To my surprise, there was Warm River, with ten of its eleven residents in the picture. Also in the frame, off in the distance, was this building.

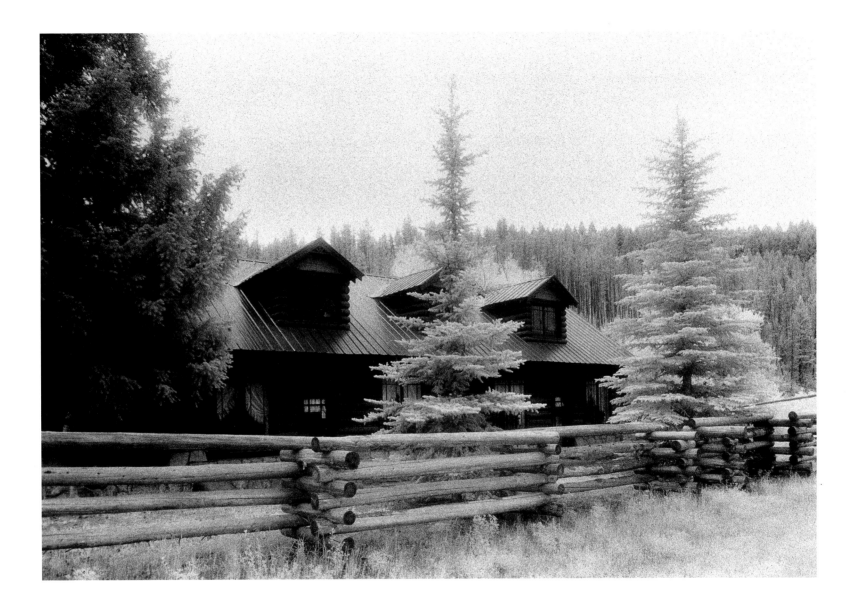

PORTLAND, OREGON

Notice in the *New Urban News,* December 1999:

"Garage-building is no longer a free-for-all in Portland, Oregon. The City Council unanimously passed an ordinance consisting of five new regulations that limit the amount of garage area allowed on the front and side of single family houses, row houses, and duplexes. Effective September 3, garages can take up no more than 50 percent of the length of a street-facing facade. . . .

"Large garages were 'a bad misfit' in [Portland's old, established neighborhoods] and in new subdivisions they created a sterile streetscape. Says Chief Planner Susan Hartnett: 'You could identify that a car lived there, but you couldn't necessarily identify that a person lived there.'"

I wrote to the owner of this downtown house in Portland, asking for information about it. Her reply:

"We know the house was built in 1906. We have lived here since 1991. Our family includes myself and my husband (James Cunningham) and our 2 daughters (Shayna Rothlein, age 13, and Leah Rothlein, age 11), our 3 cats (Sauvie, Oreo, and Tyger) and 2 gold fish."
—Joan Rothlein

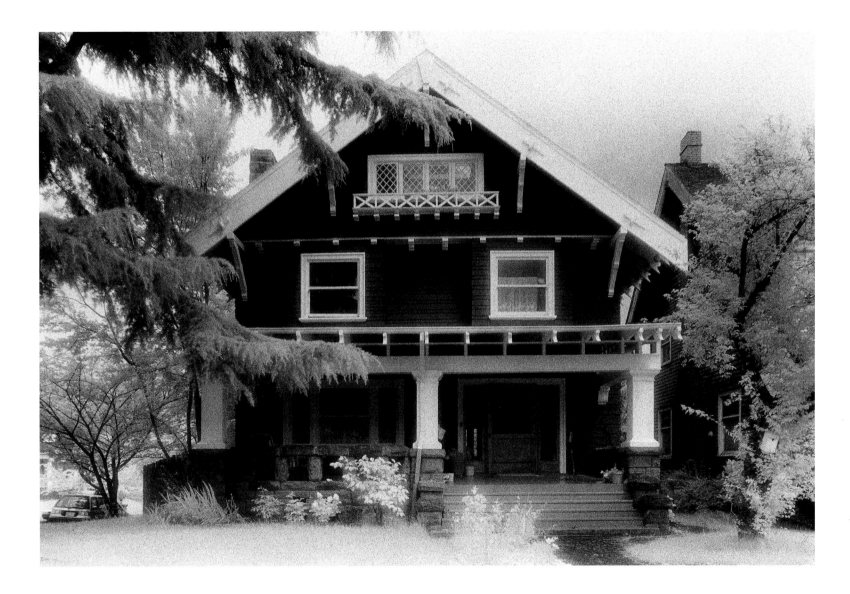

Sequim is a Klallam Indian word meaning "calm waters." The town enjoys a dry, sunny climate, protected from Pacific coastal rains by the Olympic Mountains. From here, high on a slope of the Olympic foothills, you can gaze out to the Strait of Juan de Fuca, in the direction of the San Juan Islands and Victoria, British Columbia. This house was unoccupied, a bit derelict, and for sale. I almost bought it on the spot.

I was in a print shop back East months later, making a photocopy of this picture, and the clerk saw it. "Oh my," she said, "now there's someplace you could live for the rest of your life."

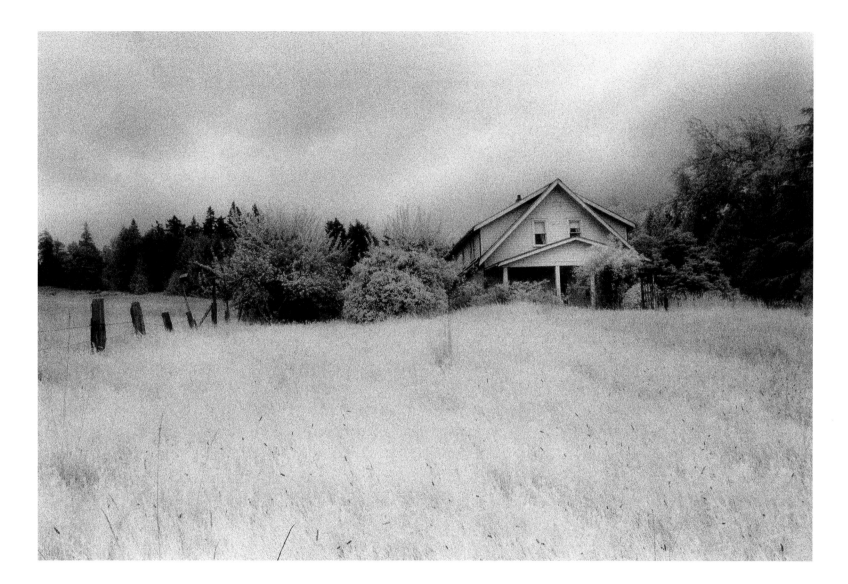

Iao Valley is one of the wettest places on earth, yet the town of Wailuku, just a few miles down the road, gets only about fifty inches of rain a year. The valley, which Mark Twain once called "The Yosemite of the Pacific," is actually the eroded crater of a volcano on West Maui. Its most prominent landform is the Iao Needle, a twelve-hundred-foot spire of foliage-covered basaltic rock. The Hawaiian word *I'ao* means "cloud supreme."

This house is part of a group of *hale kahiko* (ancient houses) set up in Kepaniwai Park to celebrate the cultures of the various immigrants to the Hawaiian Islands over the centuries. The descendants of the first Polynesian settlers, who arrived by outrigger canoe around A.D. 500, are the native Hawaiians of today, but they are outnumbered collectively by descendants of Japanese, Chinese, Filipino, Russian, Korean, Spanish, and Portuguese immigrants, many of whom came to work on sugar plantations in the nineteenth century and pineapple plantations in the twentieth. This picture shows the Filipino house.

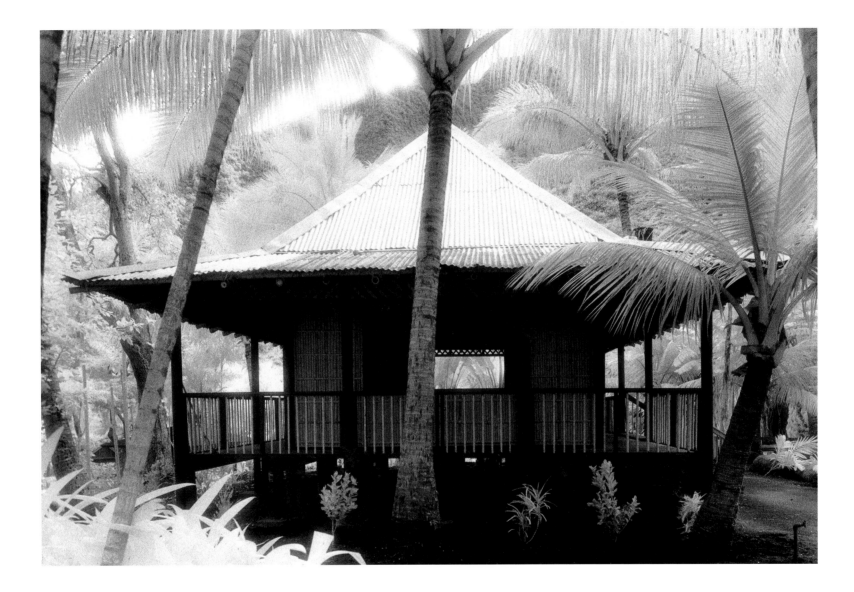

Here is where they go when they can't take the Lower Forty-Eight any more. More residents of Alaska, over 70 percent in fact, have moved from other states than are native-born Alaskans.

Many of the new arrivals get here with no place to live and very little money. If it's summer, they can put up a platform tent and live in that while they're building a cabin, racing the weather and the encroaching darkness. If they can hang on for six months, they become eligible for the annual payment of about two thousand dollars to each resident from the state's Permanent Fund, collected from mineral lease royalties.

It's hard to put a number on it, but it's a good bet that half of them don't make it. Winter comes, and there's no cabin.

They go back home.

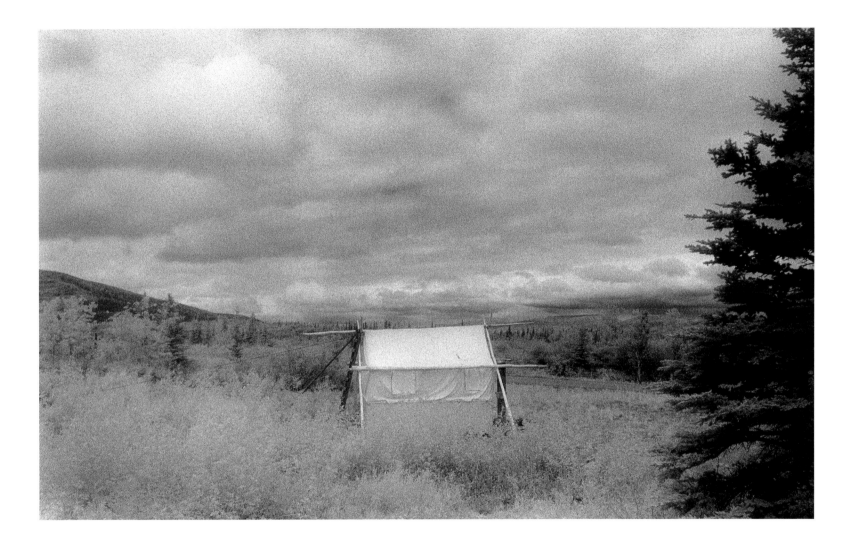

SELECTED BIBLIOGRAPHY

Carley, Rachel. *The Visual Dictionary of American Domestic Architecture*. New York: Henry Holt, 1994.

Frazier, Ian. *Great Plains*. New York: Farrar, Straus & Giroux, 1989.

The Great Hurricane and Tidal Wave, Rhode Island. Providence: Providence Journal Co., 1938.

Historic and Architectural Resources of Jamestown, Rhode Island. Providence: Rhode Island Historical Preservation & Heritage Commission, 1995.

Historic Buildings along South Temple Street. Salt Lake City: Utah Heritage Foundation, 1980.

Jakle, John A., Robert W. Bastian, and Douglas K. Meyer. *Common Houses in America's Small Towns: The Atlantic Seaboard to the Mississippi Valley*. Athens: University of Georgia Press, 1989.

Kunstler, James Howard. *The Geography of Nowhere*. New York: Simon & Schuster, 1993.

————. *Home from Nowhere*. New York: Simon & Schuster, 1996.

McAlester, Virginia, and Lee McAlester. *A Field Guide to American Houses*. New York: Alfred A. Knopf, 1989.

New Urban News. Volume 4, Number 6, November–December 1999.

"Population: A Lively Introduction," Population Reference Bureau, 1998. www.prb.org/pubs/bulletin/bu53-3/part2.htm

Sullivan, Buddy. *Self-guided Walking Tour of Old-Town Darien and a Driving Tour of Coastal McIntosh County*. Darien, Ga.: McIntosh County Chamber of Commerce, 1989.

Welcome to Darien and McIntosh County, Georgia. Darien, Ga.: McIntosh County Chamber of Commerce, 1987.

ACKNOWLEDGMENTS

First I would like to thank Brownie, Earnest, the Gray Car, the Blue Car, and the Burner, my five reliable Honda Civics, which got me home safe and sound. (Don't ask why I had to use five of them if they're so reliable. It's a long story; suffice it to say they all performed magnificently.)

Loving thanks to all my dear friends and family who wished me well on these journeys. Extra thanks to friends and colleagues who helped with the book or supported my grant applications, particularly Margetty Coe and Deborah Larkin, whose discerning eyes and thoughtful sensibilities were always there for me. Bless you, Deb, for your great work on that intractable map.

I'm very grateful for ongoing encouragement from fellow photographer-writers Stephen Perloff and Brian Peterson. Thanks also go to Jeanne Birdsall, Jack Carnell, Frank Carroll, Peter Edidin, Alida Fish, Linnea Hamer, Steven Izenour, Elizabeth Kostova, Joe Kramer, John Langdon, Lynn Langdon, Larry Mann, Martha (Chahroudi) Mock, Ken Newbaker, Sidney Tillim, and Robert Venturi. Thanks, also, to photographers who graciously advised me about book publishing and whose books and sense of adventure inspire me: Andrew Borowiec, Paula Chamlee, David Freese, David Graham, Stanley Greenberg, Sally Mann, David Plowden, Michael A. Smith, and Mark Weidman. Though they probably don't remember me, I won't forget the kindness and honesty with which Ina and Philip Trager assessed this project at a time and place when those qualities were otherwise in short supply.

Thanks to all the people who helped me find houses or information about them and to those who opened their doors to me as I traveled, especially

Robert Skaler in Philadelphia, Pennsylvania
Nellie and Bob Sabin in Katonah, New York
Matt Darrow, Hugh Montgomery, Bill Hunt,
 and Carol Keiser in Putney, Vermont
Ken and Chip Sorlien in Centre Harbor,
 New Hampshire
Roger Sorlien in Sandwich, New Hampshire
Louise Ewing and Jenny Ewing Elliott in Hancock,
 New Hampshire
Pam and Stephen Pace in Stonington, Maine

Ashley Roland in Portland, Maine

Kevin Perry in Peters Valley, New Jersey

Judith Dollenmayer in Washington, D.C.

David Lander, Susan Icove, Chris Prokosch, and
 Shannon Green in Floyd, Virginia

Charlotte and Harry Dinham and Craig Roberts in
 Mobile, Alabama

Mary Ann and Ken Schaefer in Elyria, Ohio

Masumi Hayashi in Cleveland, Ohio

Alan Feuer in Detroit, Michigan

Paul Camfield in Fredericksburg, Texas

Ron Bingham and Marty Lang in Brownville,
 Nebraska

Paul Bentz in Eureka, South Dakota

Jim and Gladys Peterson and Paul McLeod in
 Missoula, Montana

Jane and Don Stromquist in Salt Lake City, Utah

George and Chrissy Sokol in Tucson, Arizona

Kyle Marie Wesendorf and Bob Isaacson in Oak
 Park, Illinois, and San Diego, California

Marianna Crawford in Portland, Oregon

Jane and Peter LaBeaume in Sequim, Washington

Charlotte (Chandrika) Sorlien McLaughlin in
 Makawao, Maui, Hawaii

Olga Von Ziegesar-Matkin in Homer, Alaska

Many thanks to the committed and visionary folks at
the Center for American Places—George F. Thompson,
president and publishing director, and Randy Jones,
editor and publishing liaison. They were great at talking
me down and, more important, at talking the book up.
At the Johns Hopkins University Press, my exemplary
manuscript editor Linda Forlifer was as attentive and
responsive as I could wish. In the Design and Produc-
tion Department, Glen Burris, Ken Sabol, and designer
Kathleen Szawiola applied their excellent taste and pro-
duced an elegant result. I also appreciated the good
humor of Editor-in-Chief Trevor Lipscombe during
contract negotiations. Cheers to all.

Thanks to the Pennsylvania Council on the Arts for
their timely fellowships and to the Venture Fund of the
University of the Arts, where I teach, for ongoing sup-
port.

Heartfelt thanks to my buddies Thad Richardson
and Frank Carlson for getting me into the darkroom,
to William Least Heat-Moon for getting me out on the
road, and to Jim Kunstler for bringing home to me
what I was seeing out there.

Love and thanks to my mother, Joanna Sorlien, and
my father, Richard Sorlien, for their generosity and pas-
sion for travel and geography. (I still know all the state
capitals, Dad.) Love to my snarky siblings, Chris, Char-
lotte, and Eric.

Finally, love and thanks to Stone and Ginny in the
little brick rowhouse on Fourth Street and to John and
Kiri in the Gates Street Victorian. You made me want to
come home after all.

SANDY SORLIEN has been photographing American landscapes and architecture since 1980. Her work is in the permanent collections of the Corcoran Gallery of Art in Washington, D.C., and the Philadelphia Museum of Art, among others. She has received several grants, including two Fellowships in Photography from the Pennsylvania Council on the Arts. Her photographs and writing on travel and photography have appeared in the *New York Times, Philadelphia Daily News, Philadelphia Inquirer Magazine, Camera & Darkroom*, and the *Photo Review.* She currently teaches photography at the University of the Arts and is working on a book about Main Streets in America.

Sandy lives in Philadelphia with her husband John Arnold and cats Otto, Ruby, and Tiger in a three-story brick Victorian with two porches.

WILLIAM LEAST HEAT-MOON is the best-selling author of the American classics *Blue Highways, PrairyErth,* and *River-Horse.* He lives in Columbia, Missouri.

The National Road
 Edited by Karl Raitz

A Guide to the National Road
 Edited by Karl Raitz

The Motel in America
 John A. Jakle, Keith A. Sculle,
 and Jefferson S. Rogers

*Fast Food: Roadside Restaurants
in the Automobile Age*
 John A. Jakle and Keith A. Sculle